The Saint John's Bible is the first completely handwritten and illuminated Bible to be commissioned by a Benedictine abbey since the advent of the printing press more than five hundred years ago. It was created entirely by hand in Wales using ancient methods, materials, and tools, including turkey, goose, and swan quills and pigments made from hand-ground minerals and precious stones. Comprising about 1,150 pages—measuring 15⅞ inches wide by 24½ inches tall—and more than 160 beautiful works of art, the Bible is seven magnificent volumes bound between boards of quarter-sawn Welsh oak.

The creation of this one-of-a-kind Bible was a twelve-year process from its planning to its completion in 2011. Renowned calligrapher and illuminator Donald Jackson served as artistic director, collaborating with scribes, artists, and theologians to hand-create the stunning lettering and exquisite illustrations that fill the volumes and enliven and make new the Word. Each illumination is its own work of art, individually designed and painted by hand, that will inspire the faithful and thrill anyone who appreciates artistic beauty.

This lovely calendar features a different one of the Bible's colorful and intricate illuminations on each weekly spread. This beautiful calendar is one that will find a place on bookshelves long after the year is over.

Visit www.saintjohnsbible.org to learn more.

Andrews McMeel
Publishing, LLC
Kansas City • Sydney • London

Illuminate:*vt*\ from *in* + *luminare* to light up, from *lumen* light. 1a: to enlighten spiritually or intellectually b: to supply or brighten with light; 2a: to make clear b: to bring to the fore; 3: to make illustrious or resplendent; 4: to decorate (as a manuscript) with gold or silver or brilliant colors or with often elaborate designs or miniature pictures.

Donald Jackson, renowned calligrapher and illuminator, served as the artistic director of *The Saint John's Bible*. The following is a list of the artists and scribes with whom he collaborated to create the script and illuminations contained within this calendar. Due to space constraints, we are unable to directly attribute each work of art and script to the respective artist. To learn more about Donald Jackson and his team, please visit *The Saint John's Bible* Web site: www.saintjohnsbible.org.

Illuminators: Donald Jackson, Hazel Dolby, Aidan Hart, Sue Hufton, Andrew Jamieson, Thomas Ingmire, Susan Leiper, Suzanne Moore, Sally Mae Joseph, Diane von Arx, Angela Swan, Chris Tomlin

Scribes: Donald Jackson, Sue Hufton, Sally Mae Joseph, Izzy Pludwinski, Brian Simpson, Susan Leiper, Angela Swan

ISBN-13: 978-1-4494-0479-6

2012

January

S	M	T	W	T	F	S
1	2	3	4	5	6	7
8	9	10	11	12	13	14
15	16	17	18	19	20	21
22	23	24	25	26	27	28
29	30	31				

February

S	M	T	W	T	F	S
			1	2	3	4
5	6	7	8	9	10	11
12	13	14	15	16	17	18
19	20	21	22	23	24	25
26	27	28	29			

March

S	M	T	W	T	F	S
				1	2	3
4	5	6	7	8	9	10
11	12	13	14	15	16	17
18	19	20	21	22	23	24
25	26	27	28	29	30	31

April

S	M	T	W	T	F	S
1	2	3	4	5	6	7
8	9	10	11	12	13	14
15	16	17	18	19	20	21
22	23	24	25	26	27	28
29	30					

May

S	M	T	W	T	F	S
		1	2	3	4	5
6	7	8	9	10	11	12
13	14	15	16	17	18	19
20	21	22	23	24	25	26
27	28	29	30	31		

June

S	M	T	W	T	F	S
					1	2
3	4	5	6	7	8	9
10	11	12	13	14	15	16
17	18	19	20	21	22	23
24	25	26	27	28	29	30

July

S	M	T	W	T	F	S
1	2	3	4	5	6	7
8	9	10	11	12	13	14
15	16	17	18	19	20	21
22	23	24	25	26	27	28
29	30	31				

August

S	M	T	W	T	F	S
			1	2	3	4
5	6	7	8	9	10	11
12	13	14	15	16	17	18
19	20	21	22	23	24	25
26	27	28	29	30	31	

September

S	M	T	W	T	F	S
						1
2	3	4	5	6	7	8
9	10	11	12	13	14	15
16	17	18	19	20	21	22
23	24	25	26	27	28	29
30						

October

S	M	T	W	T	F	S
	1	2	3	4	5	6
7	8	9	10	11	12	13
14	15	16	17	18	19	20
21	22	23	24	25	26	27
28	29	30	31			

November

S	M	T	W	T	F	S
				1	2	3
4	5	6	7	8	9	10
11	12	13	14	15	16	17
18	19	20	21	22	23	24
25	26	27	28	29	30	

December

S	M	T	W	T	F	S
						1
2	3	4	5	6	7	8
9	10	11	12	13	14	15
16	17	18	19	20	21	22
23	24	25	26	27	28	29
30	31					

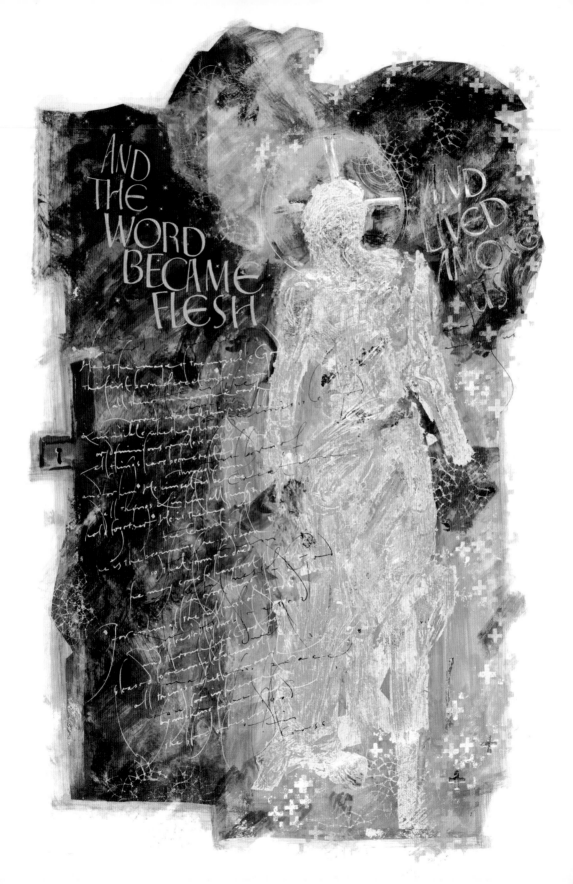

AND
THE
WORD
BECAME
FLESH

AND
LIVED
AMONG
US

January

S	M	T	W	T	F	S
1	2	3	4	5	6	7
8	9	10	11	12	13	14
15	16	17	18	19	20	21
22	23	24	25	26	27	28
29	30	31				

January

New Year's Day

Kwanzaa ends (USA)

Sunday
1

New Year's Day (observed) (Ireland, NZ, UK, Australia)

Monday
2

Bank Holiday (UK—Scotland)

Tuesday
3

Wednesday
4

Thursday
5

Friday
6

Saturday
7

JOHN 1:1-34 *And the Word became flesh and lived among us, and we have seen his glory, the glory as of a father's only son, full of grace and truth. (1:14)*

you come and reign over us.'
15 And the bramble said to the trees,
 'If in good faith you are anointing me king over you,
 then come and take refuge in my shade;
 but if not, let fire come out of the bramble
 and devour the cedars of Lebanon.'

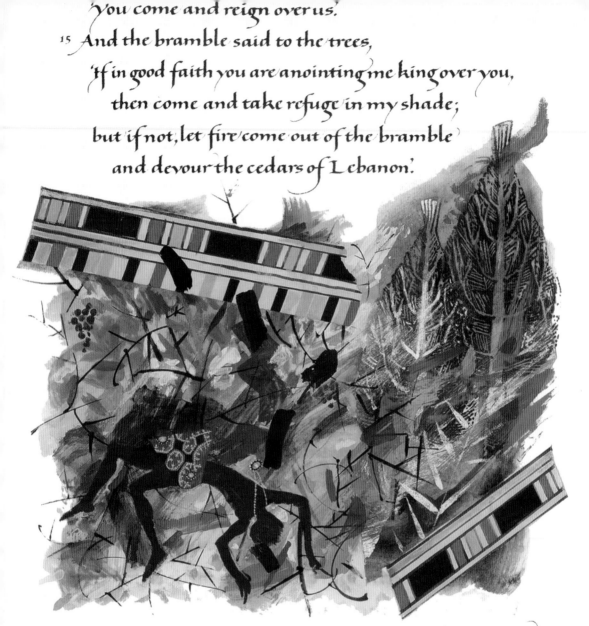

16 "Now therefore, if you acted in good faith & honor
when you made Abimelech king, and if you have
dealt well with Jerubbaal and his house, and have
done to him as his actions deserved—17 for my father
fought for you, and risked his life, and rescued you
from the hand of Midian; 18 but you have risen up
against my father's house this day, and have killed
his sons, seventy men on one stone, and have made

January

S	M	T	W	T	F	S
1	2	3	4	5	6	7
8	9	10	11	12	13	14
15	16	17	18	19	20	21
22	23	24	25	26	27	28
29	30	31				

January

Sunday
8

Monday
9

Tuesday
10

Wednesday
11

Thursday
12

Friday
13

Saturday
14

JUDGES 9 *And the bramble said to the trees, "If in good faith you are anointing me king over you, then come and take refuge in my shade; but if not, let fire come out of the bramble and devour the cedars of Lebanon." (9:15)*

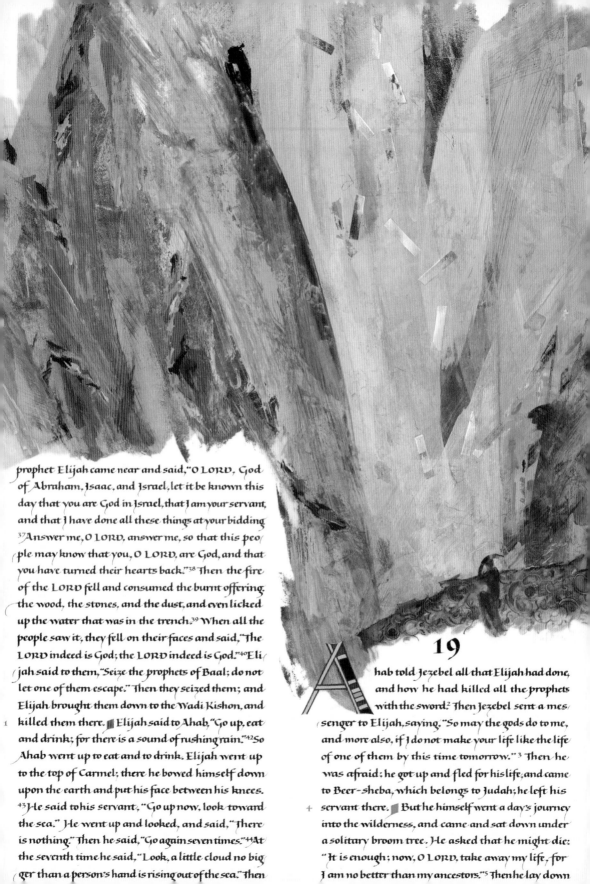

prophet Elijah came near and said, "O LORD, God of Abraham, Isaac, and Israel, let it be known this day that you are God in Israel, that I am your servant, and that I have done all these things at your bidding. ³⁷Answer me, O LORD, answer me, so that this people may know that you, O LORD, are God, and that you have turned their hearts back." ³⁸Then the fire of the LORD fell and consumed the burnt offering, the wood, the stones, and the dust, and even licked up the water that was in the trench. ³⁹When all the people saw it, they fell on their faces and said, "The LORD indeed is God; the LORD indeed is God." ⁴⁰Elijah said to them, "Seize the prophets of Baal; do not let one of them escape." Then they seized them; and Elijah brought them down to the Wadi Kishon, and killed them there. ▌ Elijah said to Ahab, "Go up, eat and drink; for there is a sound of rushing rain." ⁴²So Ahab went up to eat and to drink. Elijah went up to the top of Carmel; there he bowed himself down upon the earth and put his face between his knees. ⁴³He said to his servant, "Go up now, look toward the sea." He went up and looked, and said, "There is nothing." Then he said, "Go again seven times." ⁴⁴At the seventh time he said, "Look, a little cloud no bigger than a person's hand is rising out of the sea." Then

19

hab told Jezebel all that Elijah had done, and how he had killed all the prophets with the sword. ² Then Jezebel sent a messenger to Elijah, saying, "So may the gods do to me, and more also, if I do not make your life like the life of one of them by this time tomorrow." ³ Then he was afraid; he got up and fled for his life, and came to Beer-sheba, which belongs to Judah; he left his servant there. ▌ But he himself went a day's journey into the wilderness, and came and sat down under a solitary broom tree. He asked that he might die: "It is enough; now, O LORD, take away my life, for I am no better than my ancestors." ⁵Then he lay down

January

S	M	T	W	T	F	S
1	2	3	4	5	6	7
8	9	10	11	12	13	14
15	16	17	18	19	20	21
22	23	24	25	26	27	28
29	30	31				

January

Sunday

15

Martin Luther King Jr.'s Birthday (observed) (USA)

Monday

16

Tuesday

17

Wednesday

18

Thursday

19

Friday

20

Saturday

21

1 KINGS 19:11-12 *And after the earthquake a fire, but the LORD was not in the fire; and after the fire a sound of sheer silence. (19:12)*

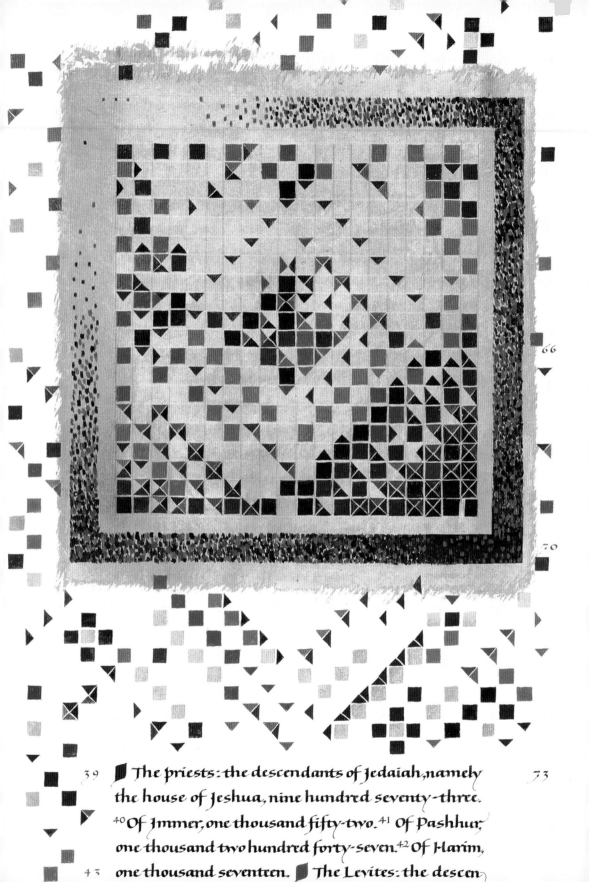

66

70

39 ❡ The priests: the descendants of Jedaiah, namely 73
the house of Jeshua, nine hundred seventy-three.
⁴⁰ Of Immer, one thousand fifty-two. ⁴¹ Of Pashhur,
one thousand two hundred forty-seven. ⁴² Of Harim,
43 one thousand seventeen. ❡ The Levites: the descen

January

S	M	T	W	T	F	S
1	2	3	4	5	6	7
8	9	10	11	12	13	14
15	16	17	18	19	20	21
22	23	24	25	26	27	28
29	30	31				

January

Sunday
22

Monday
23

Tuesday
24

Wednesday
25

Australia Day

Thursday
26

Friday
27

Saturday
28

NEHEMIAH 8 *Then he said to them, "Go your way, eat the fat and drink sweet wine and send portions of them to those for whom nothing is prepared, for this day is holy to our* LORD; *and do not be grieved, for the joy of the* LORD *is your strength." (8:10)*

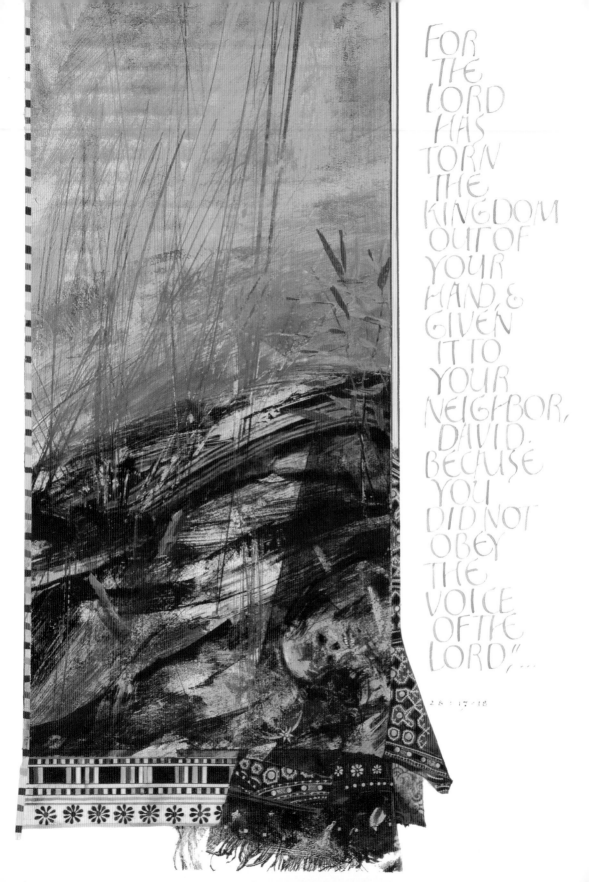

"FOR THE LORD HAS TORN THE KINGDOM OUT OF YOUR HAND & GIVEN IT TO YOUR NEIGHBOR, DAVID. BECAUSE YOU DID NOT OBEY THE VOICE OF THE LORD"...

28 : 17-18

January

S	M	T	W	T	F	S
1	2	3	4	5	6	7
8	9	10	11	12	13	14
15	16	17	18	19	20	21
22	23	24	25	26	27	28
29	30	31				

February

S	M	T	W	T	F	S	
				1	2	3	4
5	6	7	8	9	10	11	
12	13	14	15	16	17	18	
19	20	21	22	23	24	25	
26	27	28	29				

Jan-Feb

Sunday

29

Monday

30

Tuesday

31

Wednesday

1

Thursday

2

Friday

3

Saturday

4

1 SAMUEL 28:3-25 *"The Lord has done to you just as he spoke by me; for the Lord has torn the kingdom out of your hand, and given it to your neighbor, David. Because you did not obey the voice of the Lord, and did not carry out his fierce wrath against Amalek, therefore the Lord has done this thing to you today." (28:17-18)*

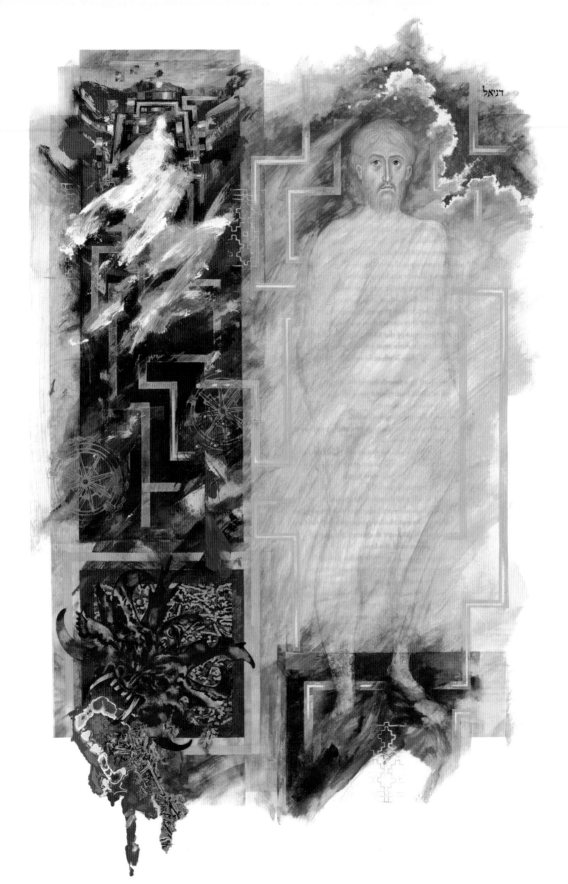
דניאל

February

S	M	T	W	T	F	S
			1	2	3	4
5	6	7	8	9	10	11
12	13	14	15	16	17	18
19	20	21	22	23	24	25
26	27	28	29			

February

Sunday
5

Waitangi Day (NZ)

Monday
6

Tuesday
7

Wednesday
8

Thursday
9

Friday
10

Saturday
11

DANIEL 7 *"But the holy ones of the Most High shall receive the kingdom and possess the kingdom forever—forever and ever." (7:18)*

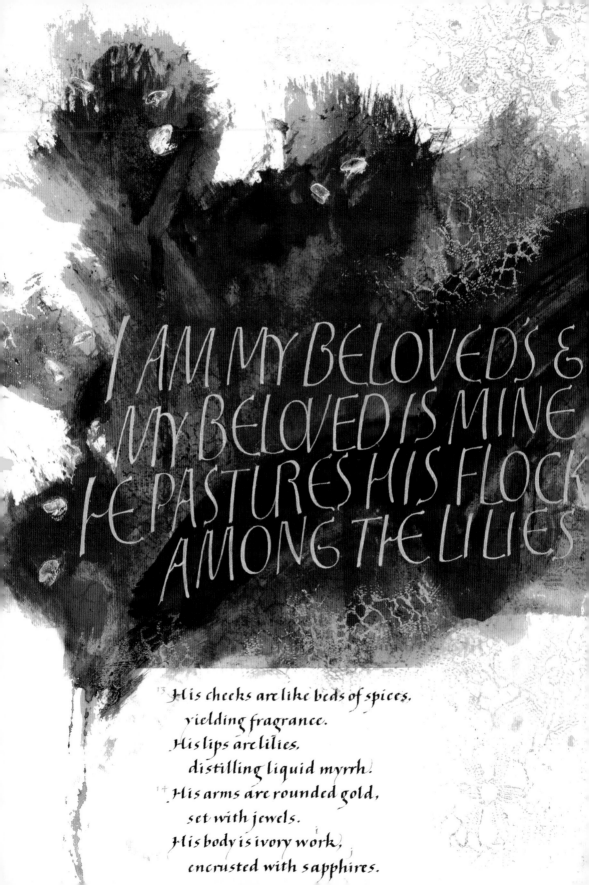

I AM MY BELOVED'S &
MY BELOVED IS MINE
HE PASTURES HIS FLOCK
AMONG THE LILIES

13 His cheeks are like beds of spices,
 yielding fragrance.
 His lips are lilies,
 distilling liquid myrrh.
14 His arms are rounded gold,
 set with jewels.
 His body is ivory work,
 encrusted with sapphires.

February

S	M	T	W	T	F	S	
				1	2	3	4
5	6	7	8	9	10	11	
12	13	14	15	16	17	18	
19	20	21	22	23	24	25	
26	27	28	29				

February

Sunday
12

Monday
13

St. Valentine's Day

Tuesday
14

Wednesday
15

Thursday
16

Friday
17

Saturday
18

SONG OF SOLOMON 5–6 *I am my beloved's and my beloved is mine; he pastures his flock among the lilies. (6:3)*

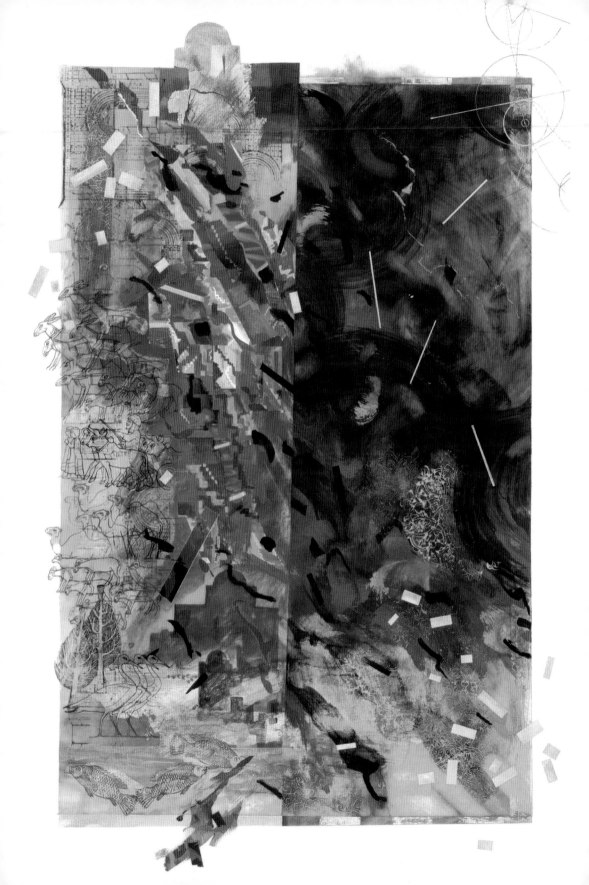

February

S	M	T	W	T	F	S
			1	2	3	4
5	6	7	8	9	10	11
12	13	14	15	16	17	18
19	20	21	22	23	24	25
26	27	28	29			

February

Sunday
19

Presidents' Day (USA)

Monday
20

Tuesday
21

Ash Wednesday

Wednesday
22

Thursday
23

Friday
24

Saturday
25

JOB 1 *He said, "Naked I came from my mother's womb, and naked shall I return there; the Lord gave, and the Lord has taken away; blessed be the name of the Lord." (1:21)*

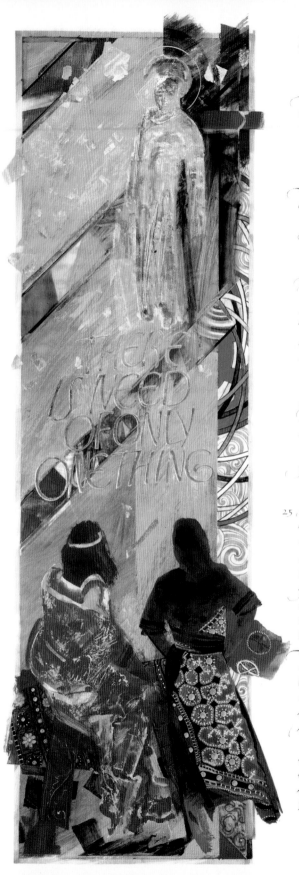

THERE IS NEED OF ONLY ONE THING

younger of them said to his father, 'Father, give me the share of the property that will belong to me.' So he divided his property between them. ¹³A few days later the younger son gathered all he had & traveled to a distant country, and there he squandered his property in dissolute living. ¹⁴When he had spent everything, a severe famine took place throughout that country, and he began to be in need. ¹⁵So he went and hired himself out to one of the citizens of that country, who sent him to his fields to feed the pigs. ¹⁶He would gladly have filled himself with the pods that the pigs were eating; and no one gave him anything. ¹⁷But when he came to himself he said, 'How many of my father's hired hands have bread enough & to spare, but here I am dying of hunger! ¹⁸I will get up and go to my father, and I will say to him, "Father, I have sinned against heaven & before you; ¹⁹I am no longer worthy to be called your son; treat me like one of your hired hands."' ²⁰So he set off and went to his father. But while he was still far off, his father saw him and was filled with compassion; he ran and put his arms around him and kissed him. ²¹Then the son said to him, 'Father, I have sinned against heaven & before you; I am no longer worthy to be called your son.' ²²But the father said to his slaves, 'Quickly, bring out a robe—the best one—and put it on him; put a ring on his finger and sandals on his feet. ²³And get the fatted calf and kill it, and let us eat and celebrate; ²⁴for this son of mine was dead and is alive again; he was lost and is found!' And they began to celebrate. ²⁵ "Now his elder son was in the field; and when he came & approached the house, he heard music and dancing. ²⁶He called one of the slaves and asked what was going on. ²⁷He replied, 'Your brother has come, and your father has killed the fatted calf, because he has got him back safe and sound.' ²⁸Then he became angry and refused to go in. His father came out and began to plead with him. ²⁹But he answered his father, 'Listen! For all these years I have been working like a slave for you, and I have never disobeyed your command; yet you have never given me even a young goat so that I might celebrate with my friends. ³⁰But when this son of yours came back, who has devoured your property with prostitutes, you killed the fatted calf for him!' ³¹Then the father said to him, 'Son, you are always with me, and all that is mine is yours. ³²But we had to celebrate & rejoice, because this brother of yours was dead and has come to life; he was lost and has been found.'"

February

S	M	T	W	T	F	S
			1	2	3	4
5	6	7	8	9	10	11
12	13	14	15	16	17	18
19	20	21	22	23	24	25
26	27	28	29			

March

S	M	T	W	T	F	S	
					1	2	3
4	5	6	7	8	9	10	
11	12	13	14	15	16	17	
18	19	20	21	22	23	24	
25	26	27	28	29	30	31	

Feb-March

Sunday
26

Monday
27

Tuesday
28

Wednesday
29

St. David's Day (UK)

Thursday
1

Friday
2

Saturday
3

LUKE 10:38-42 *"There is need of only one thing. Mary has chosen the better part, which will not be taken away from her." (10:42)*

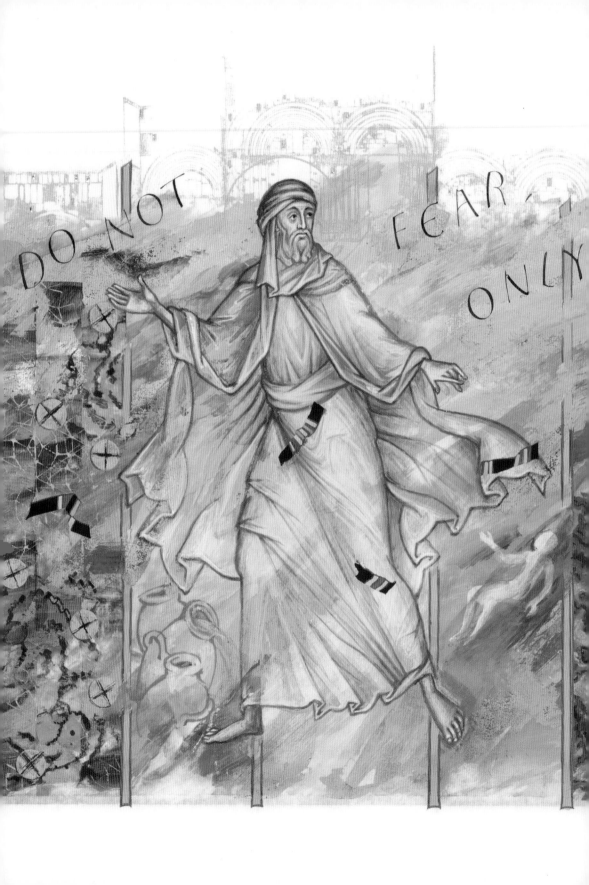

March

S	M	T	W	T	F	S	
					1	2	3
4	5	6	7	8	9	10	
11	12	13	14	15	16	17	
18	19	20	21	22	23	24	
25	26	27	28	29	30	31	

March

*Begins at sundown the previous day

Sunday
4

Labour Day (Australia—WA)

Monday
5

Tuesday
6

Wednesday
7

Purim*

International Women's Day

Thursday
8

Friday
9

Saturday
10

2 KINGS 4–9 *Elisha sent a messenger to him, saying, "Go, wash in the Jordan seven times, and your flesh shall be restored and you shall be clean." (5:10)*

THE LORD
BLESS YOU
AND KEEP YOU;
THE LORD MAKE
HIS FACE TO SHINE
UPON YOU, AND
BE GRACIOUS
TO YOU;
THE LORD
LIFT UP HIS
COUNTENANCE
UPON YOU,
AND GIVE YOU
PEACE.

March

S	M	T	W	T	F	S	
					1	2	3
4	5	6	7	8	9	10	
11	12	13	14	15	16	17	
18	19	20	21	22	23	24	
25	26	27	28	29	30	31	

March

Sunday
11

Eight Hours Day (Australia—TAS)

Labour Day (Australia—VIC)

Canberra Day (Australia—ACT)

Commonwealth Day (Australia, Canada, NZ, UK)

Monday
12

Tuesday
13

Wednesday
14

Thursday
15

Friday
16

St. Patrick's Day

Saturday
17

NUMBERS 6 *The Lord bless you and keep you; the Lord make his face to shine upon you, and be gracious to you; the Lord lift up his countenance upon you, and give you peace. So they shall put my name on the Israelites, and I will bless them. (6:24-27)*

My soul magnifies the Lord,
and my spirit rejoices in God my Savior,
48 for he has looked with favor
on the lowliness of his servant.
Surely, from now on all generations
will call me blessed;
49 for the Mighty One has done
great things for me,
and holy is his name.
50 His mercy is for those who fear him
from generation to generation.
51 He has shown strength with his arm;
he has scattered the proud
in the thoughts of their hearts.
52 He has brought down the
powerful from their thrones,
and lifted up the lowly;
53 he has filled the hungry with good things,
and sent the rich away empty.
54 He has helped his servant Israel,
in remembrance of his mercy,
55 according to the promise he
made to our ancestors,
to Abraham & to his descendants forever.

56 And Mary remained with her about three months
57 and then returned to her home. Now the time
came for Elizabeth to give birth, and she bore a son.
58 Her neighbors and relatives heard that the Lord
had shown his great mercy to her, and they rejoiced
59 with her. On the eighth day they came to circum-
cise the child, and they were going to name him
Zechariah after his father. 60 But his mother said,
"No; he is to be called John." 61 They said to her, "None
of your relatives has this name." 62 Then they began
motioning to his father to find out what name he
wanted to give him. 63 He asked for a writing tablet
& wrote, "His name is John." And all of them were
amazed. 64 Immediately his mouth was opened &
his tongue freed, and he began to speak, praising
God. 65 Fear came over all their neighbors, and all
these things were talked about throughout the en-
tire hill country of Judea. 66 All who heard them
pondered them & said, "What then will this child
become?" For, indeed, the hand of the Lord was
67 with him. Then his father Zechariah was filled
with the Holy Spirit and spoke this prophecy:

Blessed be the Lord God of Israel,
for he has looked favorably
on his people and redeemed them.
He has raised up a mighty savior for us
in the house of his servant David,
70 as he spoke through the mouth
of his holy prophets from of old,
71 that we would be saved from our
enemies and from the hand
of all who hate us.
Thus he has shown the mercy
promised to our ancestors,
& has remembered his holy covenant,
73 the oath that he swore

March

S	M	T	W	T	F	S	
					1	2	3
4	5	6	7	8	9	10	
11	12	13	14	15	16	17	
18	19	20	21	22	23	24	
25	26	27	28	29	30	31	

March

Mothering Sunday (Ireland, UK)

Sunday
18

Monday
19

Tuesday
20

Wednesday
21

Thursday
22

Friday
23

Saturday
24

LUKE 1:46-75 *And Mary said, "My soul magnifies the Lord, and my spirit rejoices in God my Savior, for he has looked with favor on the lowliness of his servant. Surely, from now on all generations will call me blessed; for the Mighty One has done great things for me, and holy is his name. (1:46–49)*

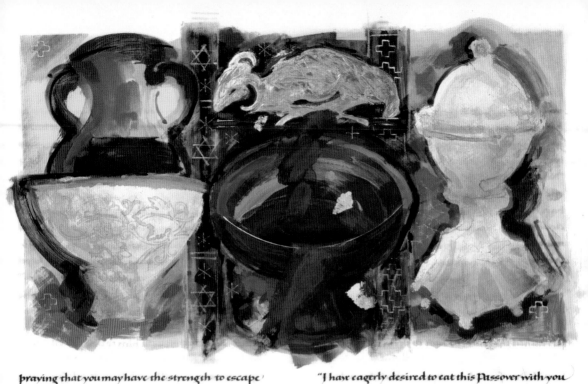

praying that you may have the strength to escape all these things that will take place, and to stand before the Son of Man." Every day he was teaching in the temple, and at night he would go out & spend the night on the Mount of Olives, as it was called. 38 And all the people would get up early in the morning to listen to him in the temple.

22

Now the festival of Unleavened Bread, which is called the Passover, was near. 2 The chief priests and the scribes were looking for a way to put Jesus to death, for they were afraid of the people. Then Satan entered into Judas called Iscariot, who was one of the twelve; 4 he went away and conferred with the chief priests and officers of the temple police about how he might betray him to them. 5 They were greatly pleased and agreed to give him money. 6 So he consented & began to look for an opportunity to betray him to them when no crowd was present. Then came the day of Unleavened Bread, on which the Passover lamb had to be sacrificed. 8 So Jesus sent Peter and John, saying, "Go and prepare the Passover meal for us that we may eat it." 9 They asked him, "Where do you want us to make preparations for it?" 10 "Listen," he said to them, "when you have entered the city, a man carrying a jar of water will meet you; follow him into the house he enters 11 and say to the owner of the house, 'The teacher asks you, "Where is the guest

"I have eagerly desired to eat this Passover with you before I suffer; 16 for I tell you, I will not eat it until it is fulfilled in the kingdom of God." 17 Then he took a cup, and after giving thanks he said, "Take this & divide it among yourselves; 18 for I tell you that from now on I will not drink of the fruit of the vine until the kingdom of God comes." 19 Then he took a loaf of bread, and when he had given thanks, he broke it and gave it to them, saying, "This is my body, which is given for you. Do this in remembrance of me." 20 And he did the same with the cup after supper, saying, "This cup that is poured out for you is the new covenant in my blood. 21 But see, the one who betrays me is with me, and his hand is on the table. 22 For the Son of Man is going as it has been determined, but woe to that one by whom he is betrayed!" 23 Then they began to ask one another which one of them it could be who would do this. A dispute also arose among them as to which one of them was to be regarded as the greatest. 25 But he said to them, "The kings of the Gentiles lord it over them; and those in authority over them are called benefactors. 26 But not so with you; rather the greatest among you must become like the youngest, and the leader like the one who serves. 27 For who is greater, the one who is at the table or the one who serves? Is it not the one at the table? But I am among you as one who serves. "You are those who have stood by me in my trials; 29 and I confer on you, just as my Father has conferred on me, a kingdom, 30 so that you may eat and drink at my table in my kingdom, and you

March

S M T W T F S
 1 2 3
4 5 6 7 8 9 10
11 12 13 14 15 16 17
18 19 20 21 22 23 24
25 26 27 28 29 30 31

March

Sunday
25

Monday
26

Tuesday
27

Wednesday
28

Thursday
29

Friday
30

Saturday
31

LUKE 22:7-38 *Then he took a loaf of bread, and when he had given thanks, he broke it and gave it to them, saying, "This is my body, which is given for you. Do this in remembrance of me." And he did the same with the cup after supper, saying, "This cup that is poured out for you is the new covenant in my blood." (22:19-20)*

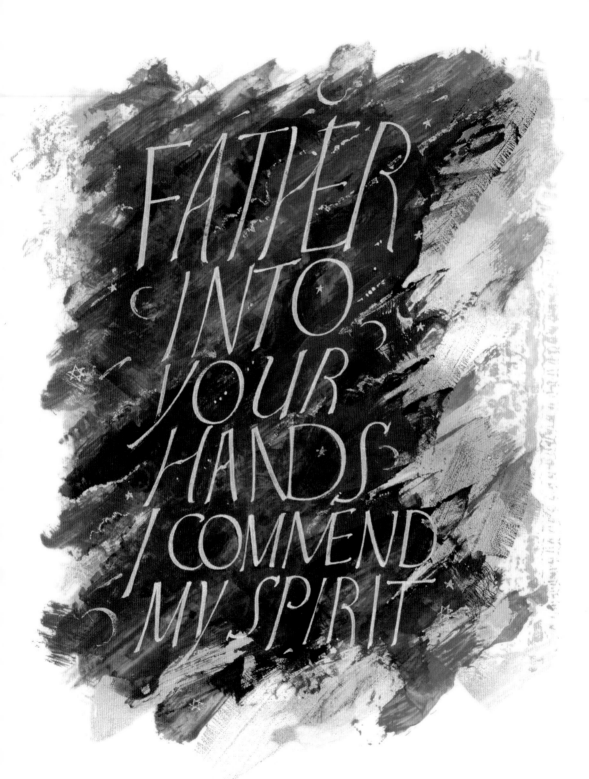

April

S	M	T	W	T	F	S
1	2	3	4	5	6	7
8	9	10	11	12	13	14
15	16	17	18	19	20	21
22	23	24	25	26	27	28
29	30					

April

*Begins at sundown the previous day

Palm Sunday

Sunday
1

Monday
2

Tuesday
3

Wednesday
4

Thursday
5

Good Friday (Western)

Friday
6

Passover*

Easter Saturday (Australia—except TAS, WA)

Saturday
7

LUKE 23:26-49 *Then Jesus, crying with a loud voice, said, "Father, into your hands I commend my spirit." Having said this, he breathed his last. (23:46)*

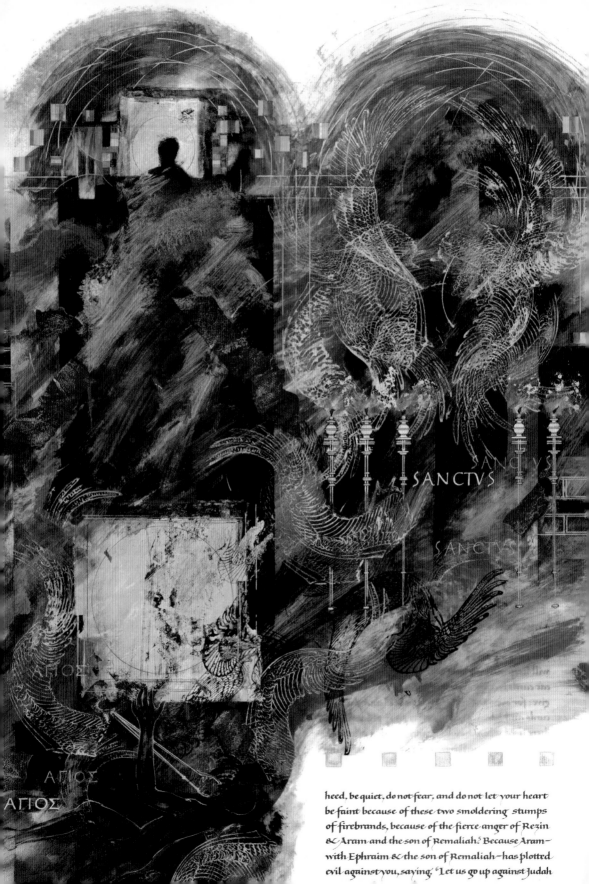

SANCTVS

SANCTVS

SANCTVS

ΑΓΙΟΣ

ΑΓΙΟΣ

ΑΓΙΟΣ

heed, be quiet, do not fear, and do not let your heart
be faint because of these two smoldering stumps
of firebrands, because of the fierce anger of Rezin
& Aram and the son of Remaliah? Because Aram—
with Ephraim & the son of Remaliah—has plotted
evil against you, saying, "Let us go up against Judah

April

S	M	T	W	T	F	S
1	2	3	4	5	6	7
8	9	10	11	12	13	14
15	16	17	18	19	20	21
22	23	24	25	26	27	28
29	30					

April

Easter (Western)

Sunday
8

Easter Monday (Australia, Canada, Ireland, NZ, UK—except Scotland)

Monday
9

Tuesday
10

Wednesday
11

Thursday
12

Holy Friday (Orthodox)

Friday
13

Passover ends

Saturday
14

ISAIAH 6 *Then I heard the voice of the Lord saying, "Whom shall I send, and who will go for us?" And I said, "Here am I; send me!" (6:8)*

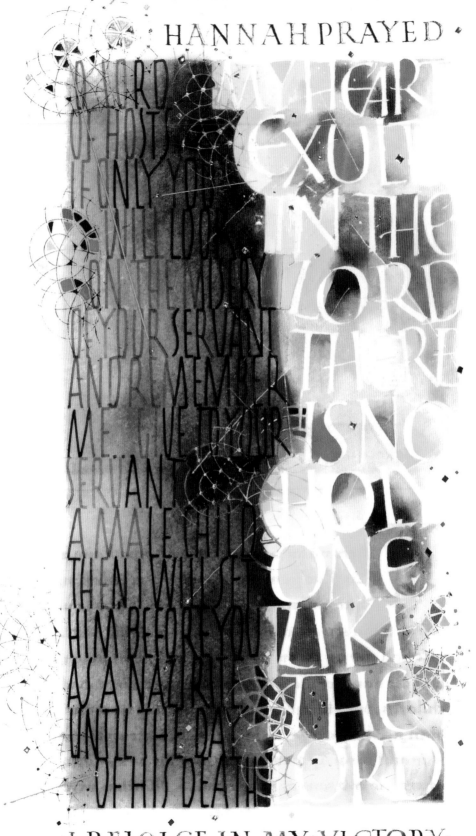

HANNAH PRAYED

O LORD MY HEART EXULT IN THE LORD OF HOSTS IF ONLY YOU WILL LOOK ON THE MISERY OF YOUR SERVANT AND REMEMBER ME GIVE YOUR SERVANT A MALE CHILD THEN I WILL SET HIM BEFORE YOU AS A NAZIRITE UNTIL THE DAY OF HIS DEATH

THERE IS NO HOLY ONE LIKE THE LORD

I REJOICE IN MY VICTORY

April

S M T W T F S
1 2 3 4 5 6 7
8 9 10 11 12 13 14
15 16 17 18 19 20 21
22 23 24 25 26 27 28
29 30

April

Easter (Orthodox)

Sunday
15

Monday
16

Tuesday
17

Wednesday
18

Thursday
19

Friday
20

Saturday
21

1 SAMUEL 1:9–2:11 *Hannah prayed and said, "My heart exults in the LORD; my strength is exalted in my God. My mouth derides my enemies, because I rejoice in my victory." (2:1)*

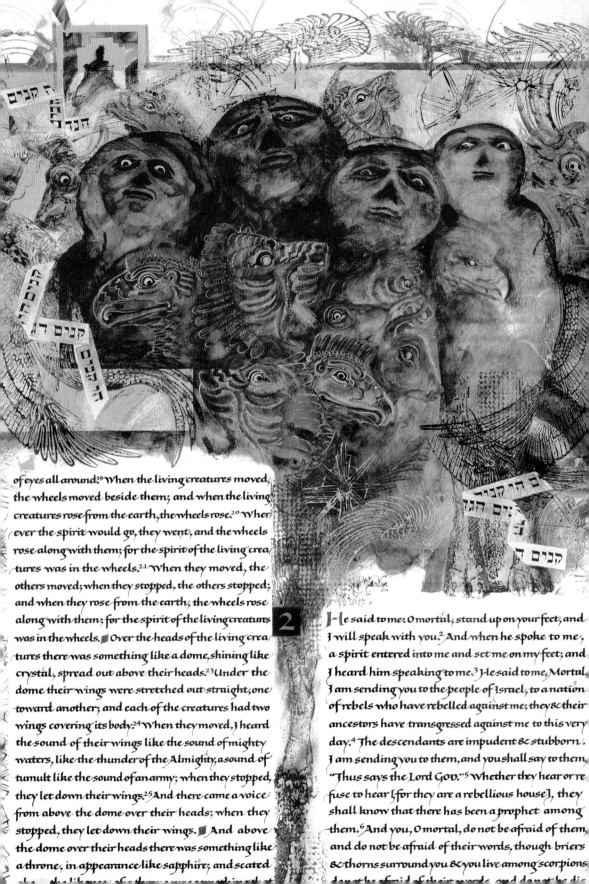

of eyes all around.[19] When the living creatures moved,
the wheels moved beside them; and when the living
creatures rose from the earth, the wheels rose.[20] Wher-
ever the spirit would go, they went, and the wheels
rose along with them; for the spirit of the living crea-
tures was in the wheels.[21] When they moved, the
others moved; when they stopped, the others stopped;
and when they rose from the earth, the wheels rose
along with them; for the spirit of the living creatures
was in the wheels. ❧ Over the heads of the living crea-
tures there was something like a dome, shining like
crystal, spread out above their heads.[23] Under the
dome their wings were stretched out straight, one
toward another; and each of the creatures had two
wings covering its body.[24] When they moved, I heard
the sound of their wings like the sound of mighty
waters, like the thunder of the Almighty, a sound of
tumult like the sound of an army; when they stopped,
they let down their wings.[25] And there came a voice
from above the dome over their heads; when they
stopped, they let down their wings. ❧ And above
the dome over their heads there was something like
a throne, in appearance like sapphire; and seated

2

He said to me: O mortal, stand up on your feet, and
I will speak with you.[2] And when he spoke to me,
a spirit entered into me and set me on my feet; and
I heard him speaking to me.[3] He said to me, Mortal,
I am sending you to the people of Israel, to a nation
of rebels who have rebelled against me; they & their
ancestors have transgressed against me to this very
day.[4] The descendants are impudent & stubborn.
I am sending you to them, and you shall say to them,
"Thus says the Lord God."[5] Whether they hear or re-
fuse to hear [for they are a rebellious house], they
shall know that there has been a prophet among
them.[6] And you, O mortal, do not be afraid of them,
and do not be afraid of their words, though briers
& thorns surround you & you live among scorpions

April

April

S M T W T F S
1 2 3 4 5 6 7
8 9 10 11 12 13 14
15 16 17 18 19 20 21
22 23 24 25 26 27 28
29 30

Earth Day

Sunday
22

St. George's Day (UK)

Monday
23

Tuesday
24

Anzac Day (NZ, Australia)

Wednesday
25

Thursday
26

Friday
27

Saturday
28

EZEKIEL 1–2 *Like the bow in a cloud on a rainy day, such was the appearance of the splendor all around. This was the appearance of the likeness of the glory of the* Lord. *(1:28)*

| April | | | | | | | | May | | | | | | |
|---|---|---|---|---|---|---|---|---|---|---|---|---|---|
| S | M | T | W | T | F | S | | S | M | T | W | T | F | S |
| 1 | 2 | 3 | 4 | 5 | 6 | 7 | | | | 1 | 2 | 3 | 4 | 5 |
| 8 | 9 | 10 | 11 | 12 | 13 | 14 | | 6 | 7 | 8 | 9 | 10 | 11 | 12 |
| 15 | 16 | 17 | 18 | 19 | 20 | 21 | | 13 | 14 | 15 | 16 | 17 | 18 | 19 |
| 22 | 23 | 24 | 25 | 26 | 27 | 28 | | 20 | 21 | 22 | 23 | 24 | 25 | 26 |
| 29 | 30 | | | | | | | 27 | 28 | 29 | 30 | 31 | | |

April-May

Sunday
29

Monday
30

Tuesday
1

Wednesday
2

Thursday
3

Friday
4

Saturday
5

MATTHEW 9:1–10:25 *When he saw the crowds, he had compassion for them, because they were harassed and helpless, like sheep without a shepherd. Then he said to his disciples, "The harvest is plentiful, but the laborers are few; therefore ask the Lord of the harvest to send out laborers into his harvest." (9:36-38)*

May

S	M	T	W	T	F	S
		1	2	3	4	5
6	7	8	9	10	11	12
13	14	15	16	17	18	19
20	21	22	23	24	25	26
27	28	29	30	31		

May

Sunday
6

Labour Day (Australia—QLD)

May Day (Australia—NT)

Early May Bank Holiday (Ireland, UK)

Monday
7

Tuesday
8

Wednesday
9

Thursday
10

Friday
11

Saturday
12

MATTHEW 8:23-27 *And he said to them, "Why are you afraid, you of little faith?" Then he got up and rebuked the winds and the sea; and there was a dead calm. They were amazed, saying, "What sort of man is this, that even the winds and the sea obey him?" (8:26-27)*

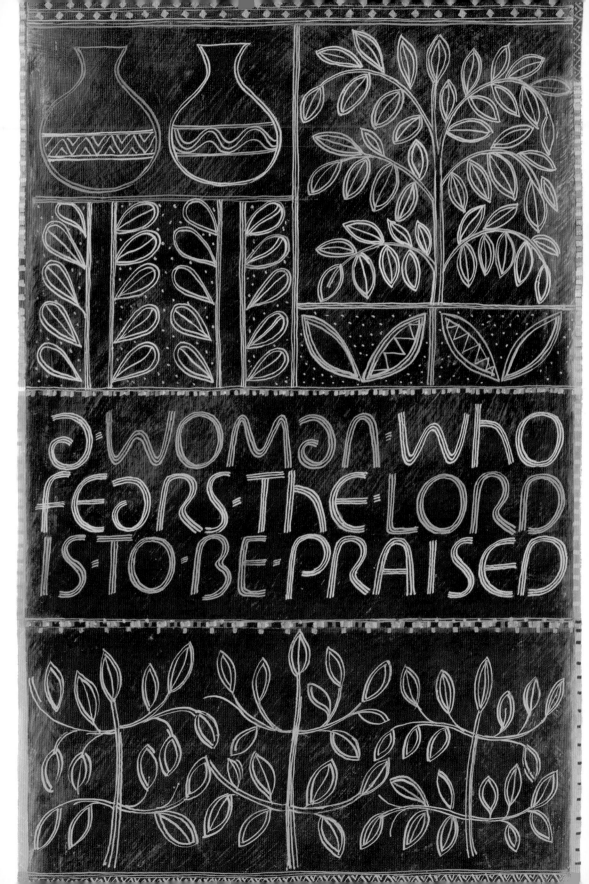

May

S	M	T	W	T	F	S
		1	2	3	4	5
6	7	8	9	10	11	12
13	14	15	16	17	18	19
20	21	22	23	24	25	26
27	28	29	30	31		

May

Mother's Day (USA, Australia, Canada, NZ)

Sunday
13

Monday
14

Tuesday
15

Wednesday
16

Thursday
17

Friday
18

Armed Forces Day (USA)

Saturday
19

PROVERBS 31:10-31 *Charm is deceitful, and beauty is vain, but a woman who fears the* LORD *is to be praised. (31:30)*

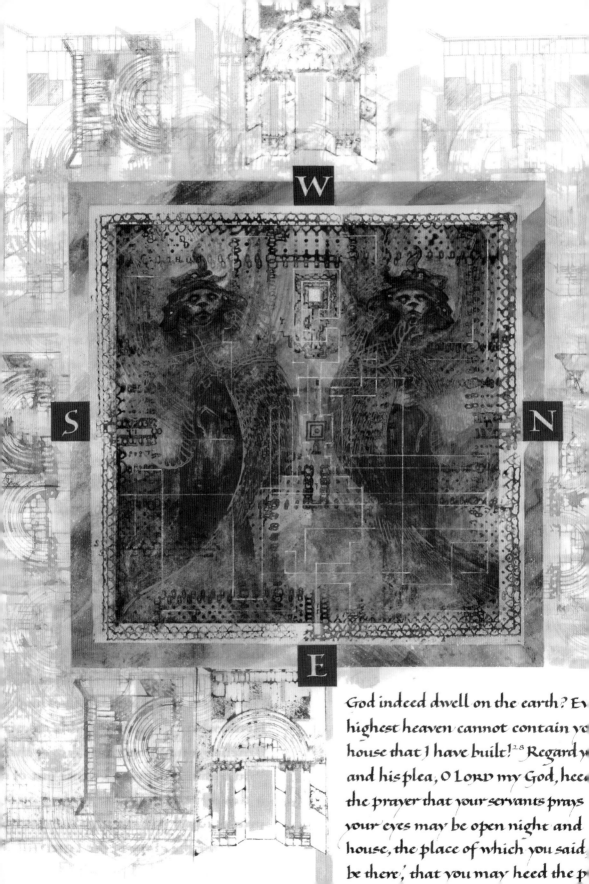

W

S

N

E

God indeed dwell on the earth? Ev
highest heaven cannot contain yo
house that I have built! [28] Regard y
and his plea, O LORD my God, hee
the prayer that your servants pray
your eyes may be open night and
house, the place of which you said
be there,' that you may heed the p

May

S	M	T	W	T	F	S
	1	2	3	4	5	
6	7	8	9	10	11	12
13	14	15	16	17	18	19
20	21	22	23	24	25	26
27	28	29	30	31		

May

Sunday
20

Victoria Day (Canada)

Monday
21

Tuesday
22

Wednesday
23

Thursday
24

Friday
25

Saturday
26

1 KINGS 8 *He said, "O LORD, God of Israel, there is no God like you in heaven above or on earth beneath, keeping covenant and steadfast love for your servants who walk before you with all their heart." (8:23)*

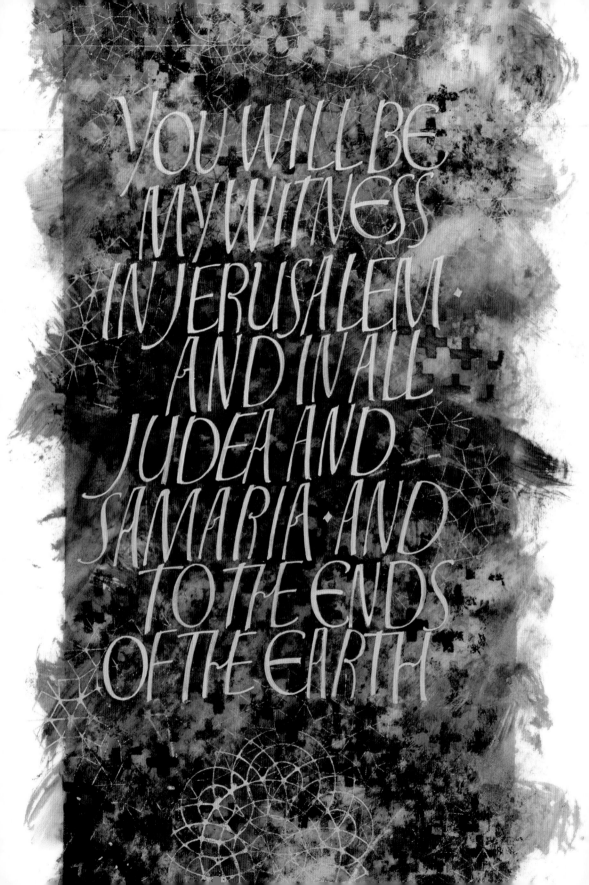

May								June						
S	M	T	W	T	F	S		S	M	T	W	T	F	S
	1	2	3	4	5								1	2
6	7	8	9	10	11	12		3	4	5	6	7	8	9
13	14	15	16	17	18	19		10	11	12	13	14	15	16
20	21	22	23	24	25	26		17	18	19	20	21	22	23
27	28	29	30	31				24	25	26	27	28	29	30

May-June

Sunday
27

Monday
28

Memorial Day (USA)

Spring Bank Holiday (UK—Scotland)

Tuesday
29

Wednesday
30

Thursday
31

Friday
1

Saturday
2

ACTS 1:3-11 *"But you will receive power when the Holy Spirit has come upon you; and you will be my witnesses in Jerusalem, in all Judea and Samaria, and to the ends of the earth." (1:8)*

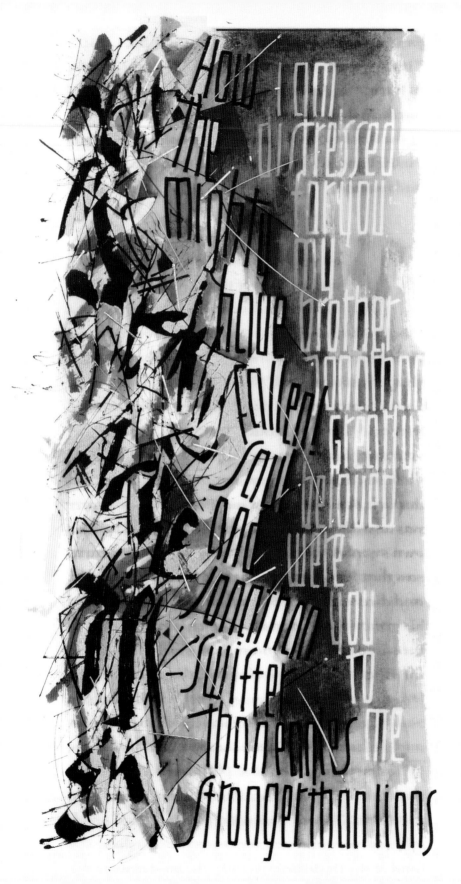

How I am distressed for you my brother Jonathan greatly beloved were you to me

How the mighty have fallen soul and Jonathan swifter than eagles stronger than lions

June

S	M	T	W	T	F	S
					1	2
3	4	5	6	7	8	9
10	11	12	13	14	15	16
17	18	19	20	21	22	23
24	25	26	27	28	29	30

June

Sunday
3

Queen's Birthday (NZ)

Foundation Day (Australia—WA)

Spring Bank Holiday (Ireland, UK—except Scotland)

Monday
4

Diamond Jubilee Holiday (UK)

Tuesday
5

Wednesday
6

Thursday
7

Friday
8

Saturday
9

2 SAMUEL 1 *How the mighty have fallen, and the weapons of war perished! (1:27)*

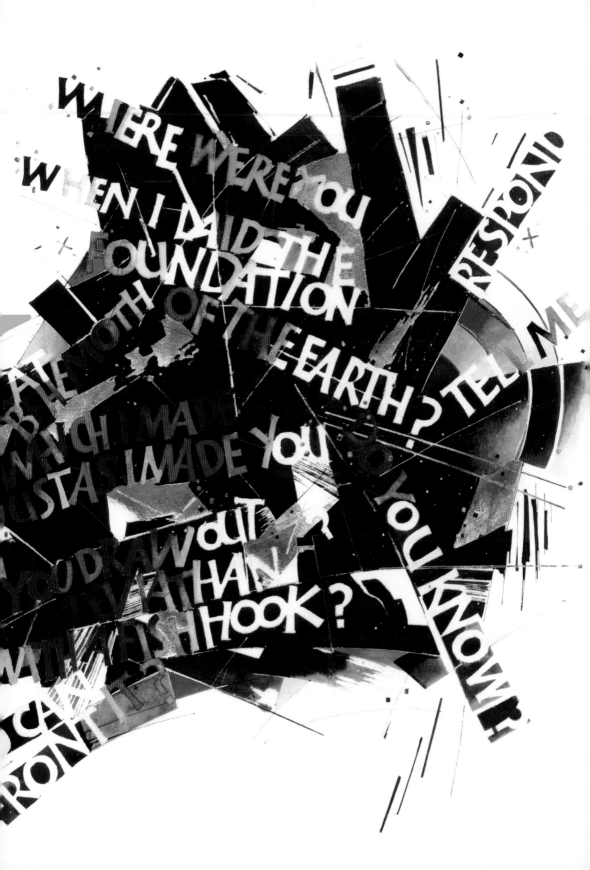

June

S	M	T	W	T	F	S
					1	2
3	4	5	6	7	8	9
10	11	12	13	14	15	16
17	18	19	20	21	22	23
24	25	26	27	28	29	30

June

Sunday
10

Queen's Birthday (Australia—except WA)

Monday
11

Tuesday
12

Wednesday
13

Flag Day (USA)

Thursday
14

Friday
15

Saturday
16

JOB 38–39 *Then the LORD answered Job out of the whirlwind: "Who is this that darkens counsel by words without knowledge? Gird up your loins like a man, I will question you, and you shall declare to me." (38:1-3)*

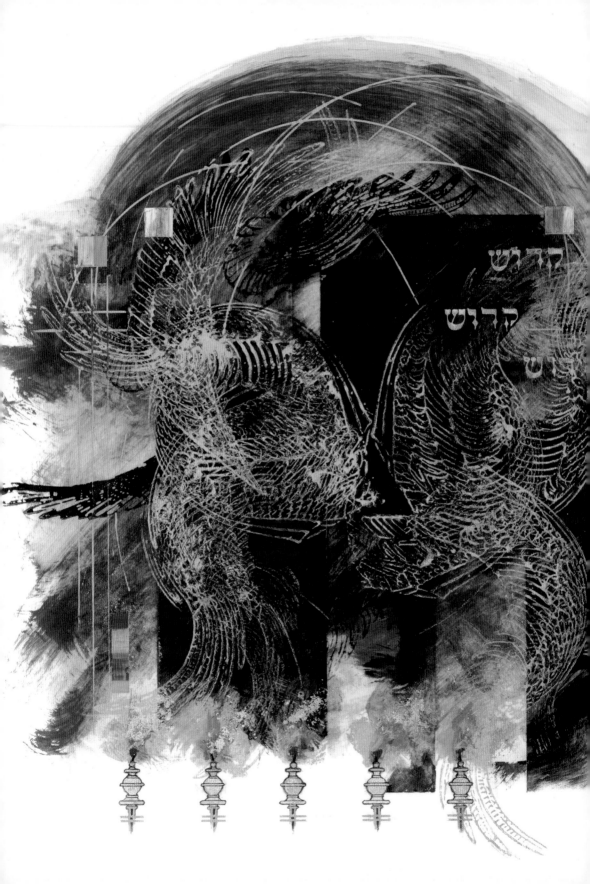

June

S	M	T	W	T	F	S
					1	2
3	4	5	6	7	8	9
10	11	12	13	14	15	16
17	18	19	20	21	22	23
24	25	26	27	28	29	30

June

Father's Day (USA, Canada, Ireland, UK)

Sunday
17

Monday
18

Tuesday
19

Wednesday
20

Thursday
21

Friday
22

Saturday
23

ISAIAH 6 *And one called to another and said; "Holy, holy, holy is the* LORD *of hosts; the whole earth is full of his glory." (6:3)*

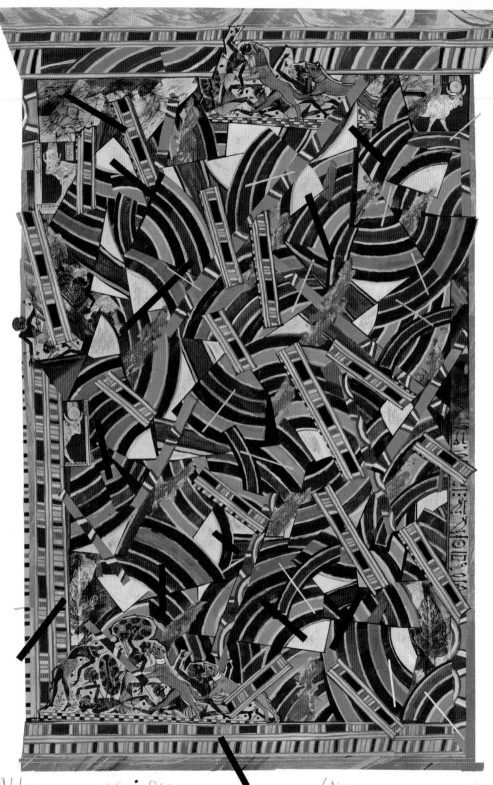

ALL . THE PEOPLE . DID WHAT . WAS RIGHT . IN THEIR . OWN EYES

June

S	M	T	W	T	F	S
					1	2
3	4	5	6	7	8	9
10	11	12	13	14	15	16
17	18	19	20	21	22	23
24	25	26	27	28	29	30

June

Sunday
24

Monday
25

Tuesday
26

Wednesday
27

Thursday
28

Friday
29

Saturday
30

JUDGES 21 *In those days there was no king in Israel; all the people did what was right in their own eyes. (21:25)*

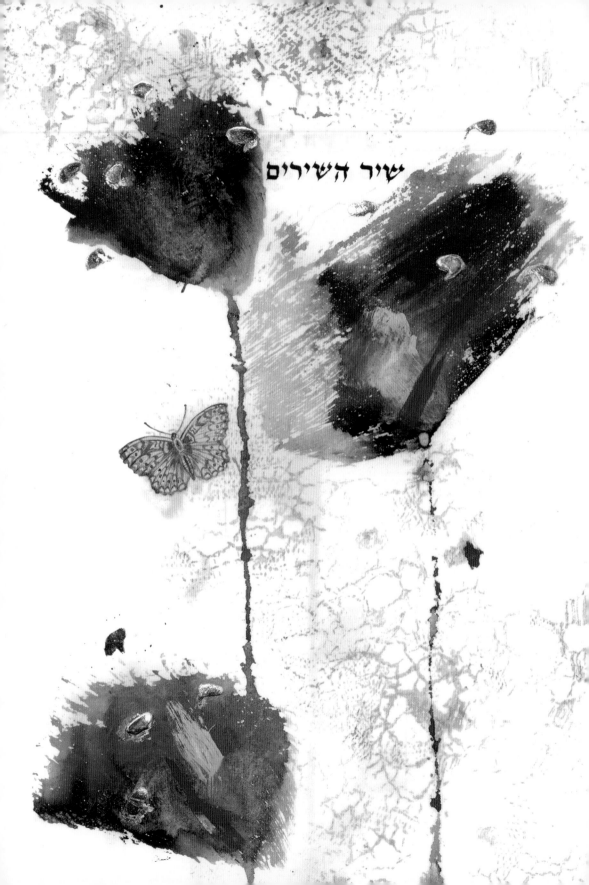

שיר השירים

July

S	M	T	W	T	F	S
1	2	3	4	5	6	7
8	9	10	11	12	13	14
15	16	17	18	19	20	21
22	23	24	25	26	27	28
29	30	31				

July

Canada Day

Sunday
1

Monday
2

Tuesday
3

Independence Day (USA)

Wednesday
4

Thursday
5

Friday
6

Saturday
7

SONG OF SOLOMON 7 *The mandrakes give forth fragrance, and over our doors are all choice fruits, new as well as old, which I have laid up for you, O my beloved. (7:13)*

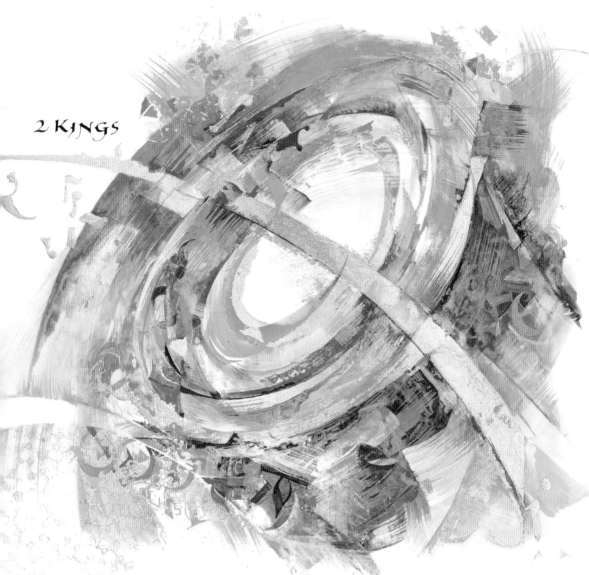

2 KINGS

against this place, and it will not be quenched.[18] But as to the king of Judah, who sent you to inquire of the LORD, thus shall you say to him, Thus says the LORD, the God of Israel: Regarding the words that you have heard,[19] because your heart was penitent, and you humbled yourself before the LORD, when you heard how I spoke against this place, & against its inhabitants, that they should become a desolation and a curse, and because you have torn your clothes and wept before me, I also have heard you, says the LORD.[20] Therefore, I will gather you to your ancestors,

July

S M T W T F S
1 2 3 4 5 6 7
8 9 10 11 12 13 14
15 16 17 18 19 20 21
22 23 24 25 26 27 28
29 30 31

July

Sunday

8

Monday

9

Tuesday

10

Wednesday

11

Thursday

12

Friday

13

Saturday

14

2 KINGS 22 *Because they have abandoned me and have made offerings to other gods, so that they have provoked me to anger with all the work of their hands, therefore my wrath will be kindled against this place, and it will not be quenched. (22:17)*

r, hear; and let those who re
r they are a rebellious house.

4

ake a brick & set it before you.
rusalem;² and put siegeworks
a siege wall against it, and cast
; set camps also against it, and
against it all around.³ Then take
ace it as an iron wall between
your face toward it, and let it
nd press the siege against it.
house of Israel. ■ Then lie on
ce the punishment of the house
shall bear their punishment
days that you lie there.⁵ For I
er of days, three hundred nine
number of the years of their
you shall bear the punishment
.⁶ When you have completed
wn a second time, but on your
the punishment of the house
I assign you, one day for each
our face toward the siege of Je
ur arm bared you shall proph
am putting cords on you so that
one side to the other until

מדבר

צדקת

ישראל

July

S	M	T	W	T	F	S	
	1	2	3	4	5	6	7
8	9	10	11	12	13	14	
15	16	17	18	19	20	21	
22	23	24	25	26	27	28	
29	30	31					

July

Sunday
15

Monday
16

Tuesday
17

Wednesday
18

Thursday
19

Ramadan

Friday
20

Saturday
21

EZEKIEL 3:1–4:11 *Then the spirit lifted me up, and as the glory of the LORD rose from its place, I heard behind me the sound of loud rumbling; it was the sound of the wings of the living creatures brushing against one another, and the sound of the wheels beside them, that sounded like a loud rumbling. (3:12-13)*

HEAR, O ISRAEL:
THE LORD OUR GOD,
THE LORD IS ONE;

30 YOU SHALL LOVE THE
LORD YOUR GOD WITH ALL
YOUR HEART, AND WITH
ALL YOUR SOUL, AND WITH
ALL YOUR MIND, AND
WITH ALL YOUR STRENGTH.

31 THE SECOND IS THIS,

'YOU SHALL LOVE YOUR
NEIGHBOR AS YOURSELF.'
THERE IS NO OTHER COMMAND-
MENT GREATER THAN THESE."

July

S	M	T	W	T	F	S
1	2	3	4	5	6	7
8	9	10	11	12	13	14
15	16	17	18	19	20	21
22	23	24	25	26	27	28
29	30	31				

July

Sunday
22

Monday
23

Tuesday
24

Wednesday
25

Thursday
26

Friday
27

Saturday
28

MARK 12:29-31 *Jesus answered, "The first is, 'Hear, O Israel: the Lord our God, the Lord is one; you shall love the Lord your God with all your heart, and with all your soul, and with all your mind, and with all your strength.' The second is this, 'You shall love your neighbor as yourself.' There is no other commandment greater than these."*

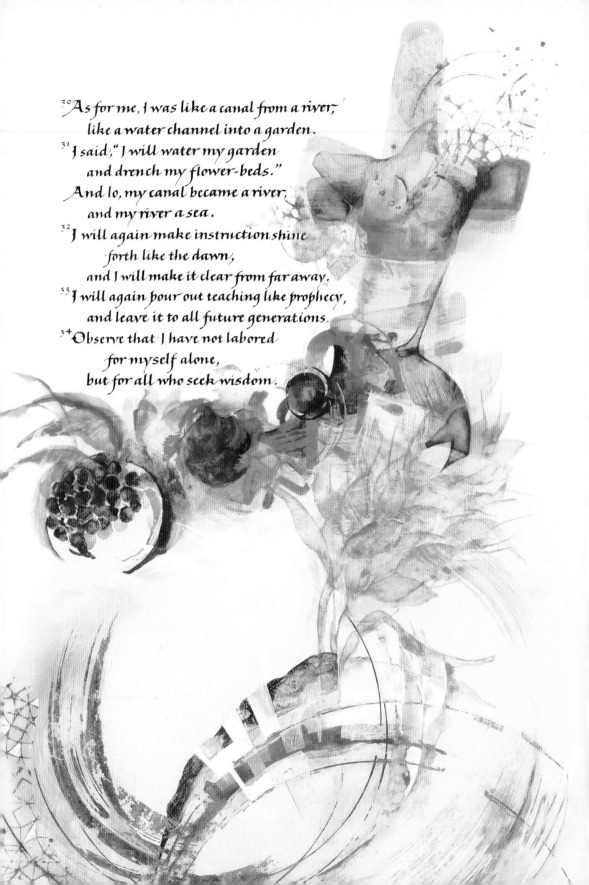

³⁰As for me, I was like a canal from a river,
 like a water channel into a garden.
³¹I said, "I will water my garden
 and drench my flower-beds."
And lo, my canal became a river,
 and my river a sea.
³²I will again make instruction shine
 forth like the dawn,
 and I will make it clear from far away.
³³I will again pour out teaching like prophecy,
 and leave it to all future generations.
³⁴Observe that I have not labored
 for myself alone,
 but for all who seek wisdom.

July

S	M	T	W	T	F	S
1	2	3	4	5	6	7
8	9	10	11	12	13	14
15	16	17	18	19	20	21
22	23	24	25	26	27	28
29	30	31				

August

S	M	T	W	T	F	S	
				1	2	3	4
5	6	7	8	9	10	11	
12	13	14	15	16	17	18	
19	20	21	22	23	24	25	
26	27	28	29	30	31		

July-August

Sunday
29

Monday
30

Tuesday
31

Wednesday
1

Thursday
2

Friday
3

Saturday
4

SIRACH 24 *"Those who eat of me will hunger for more, and those who drink of me will thirst for more. Whoever obeys me will not be put to shame, and those who work with me will not sin."* *(24:21-22)*

ever I have moved about among all the people of Israel, did I ever speak a word with any of the tribal leaders of Israel, whom I commanded to shepherd my people Israel, saying, "Why have you not built me a house of cedar?" [8] Now therefore thus you shall say to my servant David: Thus says the LORD of hosts: I took you from the pasture, from following the sheep to be prince over my people Israel; [9] and I have been with you wherever you went, and have cut off all your enemies from before you; and I will make for you a great name, like the name of the great ones of the earth. [10] And I will appoint a place for my people Israel and will plant them, so that they may live in their own place, and be disturbed no more; and evildoers shall afflict them no more, as formerly, [11] from the time that I appointed judges over my people Israel; and I will give you rest from all your enemies. Moreover the LORD declares to you that the LORD will make you a house. [12] When your days are fulfilled and you lie down with your ancestors, I will raise up your offspring after you, who shall come forth from your body, and I will establish his kingdom. [13] He shall build a house for my name, and I will establish the throne of his kingdom forever. [14] I will be a father to him, and he shall be a son to me. When he commits iniquity, I will punish him with a rod such as mortals use, with blows inflicted by human beings. [15] But I will not take my steadfast love from him, as I took it from Saul, whom I put away from before you. [16] Your house and your kingdom shall be made sure forever before me; your throne shall be established forever. [17] In accordance with all these words & with all this vision, Nathan spoke to David.

8 Then King David went in & sat before the LORD, and said, "Who am I, O Lord GOD, and what is my house, that you have brought me thus far? [19] And yet this was a small thing in your eyes, O Lord GOD; you have spoken also of your servant's house for a great while to come. May this be instruction for the people, O Lord GOD! [20] And what more can David say to you? For you know your servant, O Lord GOD! [21] Because of your promise, and according to your own heart, you have wrought all this greatness, so that your servant may know it. [22] Therefore you are great, O LORD God; for there is no one like you, and there is no God besides you, according to all that we have heard with our ears. [23] Who is like your people, like Israel? Is there another nation on earth whose

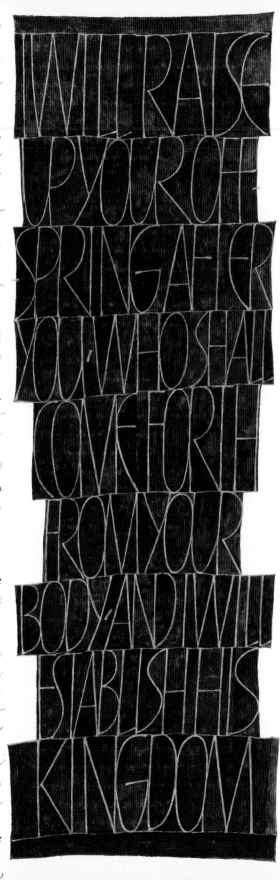

I WILL RAISE UP YOUR OFFSPRING AFTER YOU, WHO SHALL COME FORTH FROM YOUR BODY, AND I WILL ESTABLISH HIS KINGDOM

August

S	M	T	W	T	F	S
			1	2	3	4
5	6	7	8	9	10	11
12	13	14	15	16	17	18
19	20	21	22	23	24	25
26	27	28	29	30	31	

August

Summer Bank Holiday (Ireland, UK—Scotland, Australia—NSW)

Picnic Day (Australia—NT)

Sunday
5

Monday
6

Tuesday
7

Wednesday
8

Thursday
9

Friday
10

Saturday
11

2 SAMUEL 7 *When your days are fulfilled and you lie down with your ancestors, I will raise up your offspring after you, who shall come forth from your body, and I will establish his kingdom. (7:12)*

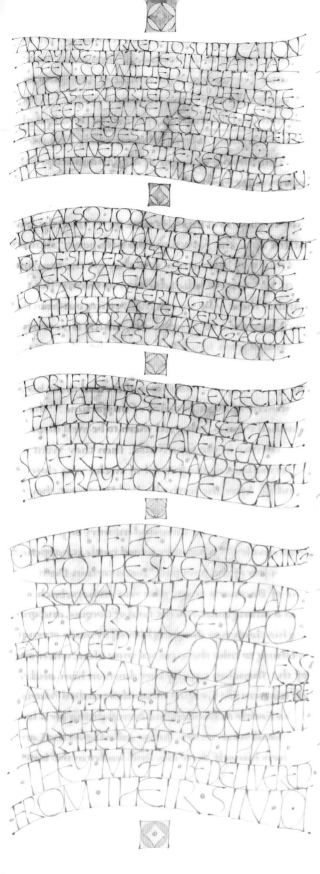

exhorted the people to keep themselves free from sin, for they had seen with their own eyes what had happened as the result of the sin of those who had fallen. 43 He also took up a collection, man by man, to the amount of two thousand drachmas of silver, and sent it to Jerusalem to provide for a sin offering. In doing this he acted very well & honorably, taking account of the resurrection. 44 For if he were not expecting that those who had fallen would rise again, it would have been superfluous and foolish to pray for the dead. 45 But if he was looking to the splendid reward that is laid up for those who fall asleep in godliness, it was a holy and pious thought. Therefore he made atonement for the dead, so that they might be delivered from their sin.

13

In the one hundred forty-ninth year word came to Judas and his men that Antiochus Eupator was coming with a great army against Judea, 2 and with him Lysias, his guardian, who had charge of the government. Each of them had a Greek force of one hundred ten thousand infantry, five thousand three hundred cavalry, twenty-two elephants, and three hundred chariots armed with scythes. Menelaus also joined them and with utter hypocrisy urged Antiochus on, not for the sake of his country's welfare, but because he thought that he would be established in office. 3 But the King of kings aroused the anger of Antiochus against the scoundrel; and when Lysias informed him that this man was to blame for all the trouble, he ordered them to take him to Beroea and to put him to death by the method that is customary in that place. 5 For there is a tower there, fifty cubits high, full of ashes, and it has a rim running around it that on all sides inclines precipitously into the ashes. 6 There they all push to destruction anyone guilty of sacrilege or notorious for other crimes. 7 By such a fate it came about that Menelaus the lawbreaker died, without even burial in the earth. 8 And this was eminently just; because he had committed many sins against the altar whose fire and ashes were holy, he met his death in ashes. The king with barbarous arrogance was coming to show the Jews things far worse than those that had been done in his father's time. 10 But when Judas heard of this, he ordered the people to call upon the Lord day and night, now if ever to help those who were on the point of being deprived of the law and their country and the holy temple, 11 and not to let the people who had just begun to revive fall into the hands

August

S	M	T	W	T	F	S
			1	2	3	4
5	6	7	8	9	10	11
12	13	14	15	16	17	18
19	20	21	22	23	24	25
26	27	28	29	30	31	

August

Sunday
12

Monday
13

Tuesday
14

Wednesday
15

Thursday
16

Friday
17

Saturday
18

2 MACCABEES 12:42-45 *For if he were not expecting that those who had fallen would rise again, it would have been superfluous and foolish to pray for the dead. (12:44)*

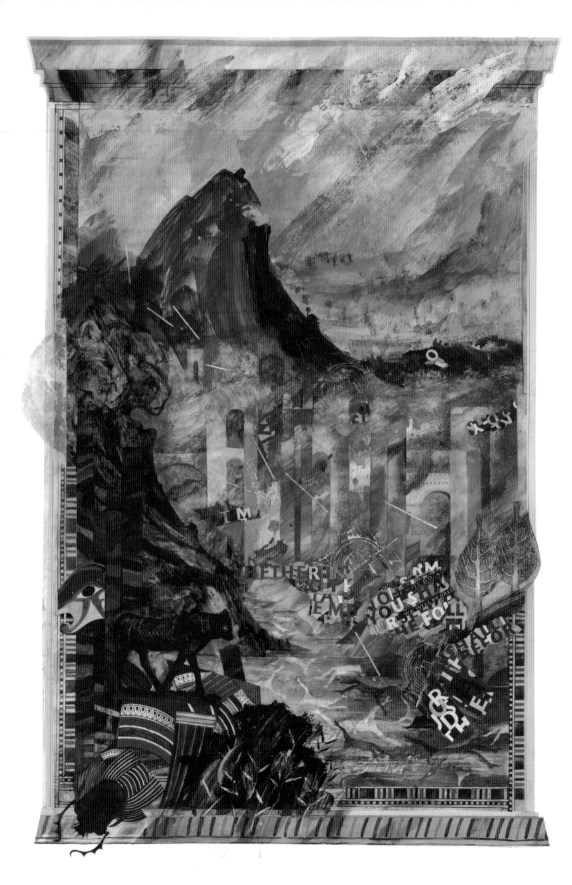

August

S M T W T F S
 1 2 3 4
5 6 7 8 9 10 11
12 13 14 15 16 17 18
19 20 21 22 23 24 25
26 27 28 29 30 31

August

Eid al-Fitr

Sunday
19

Monday
20

Tuesday
21

Wednesday
22

Thursday
23

Friday
24

Saturday
25

JOSHUA 3–4 *While all Israel were crossing over on dry ground, the priests who bore the ark of the covenant of the LORD stood on dry ground in the middle of the Jordan, until the entire nation finished crossing over the Jordan. (3:17)*

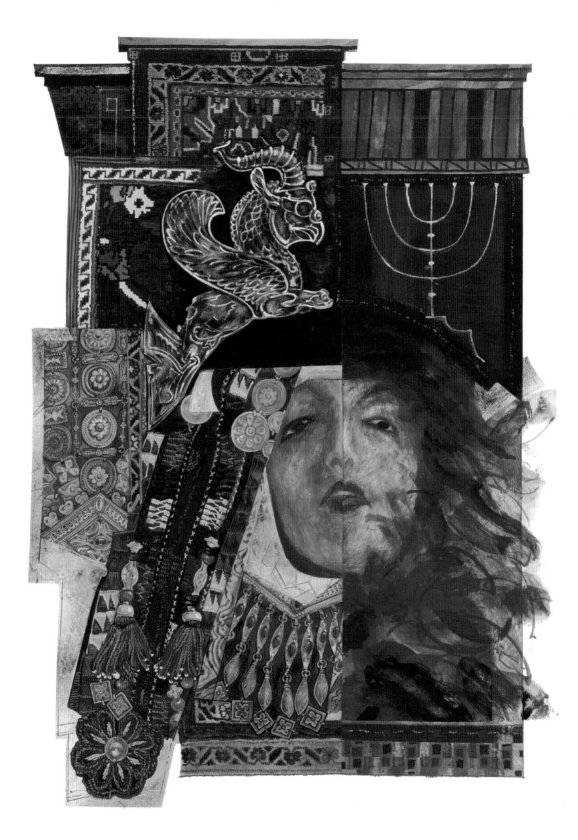

August

S	M	T	W	T	F	S
			1	2	3	4
5	6	7	8	9	10	11
12	13	14	15	16	17	18
19	20	21	22	23	24	25
26	27	28	29	30	31	

September

S	M	T	W	T	F	S
						1
2	3	4	5	6	7	8
9	10	11	12	13	14	15
16	17	18	19	20	21	22
23	24	25	26	27	28	29
30						

Aug-Sept

Sunday
26

Summer Bank Holiday (UK—except Scotland)

Monday
27

Tuesday
28

Wednesday
29

Thursday
30

Friday
31

Saturday
1

ESTHER 14:11-19 *"O God, whose might is over all, hear the voice of the despairing, and save us from the hands of evildoers. And save me from my fear!" (14:19)*

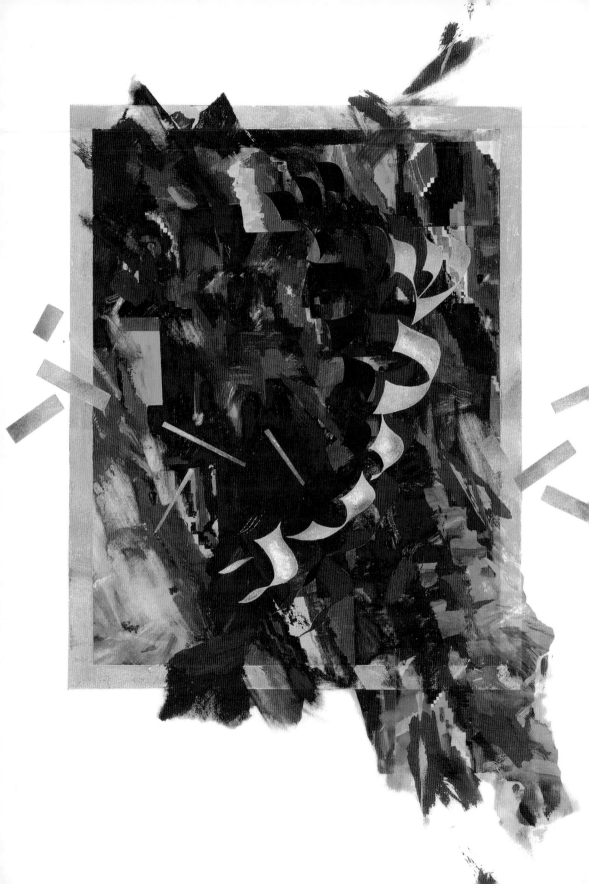

September

S	M	T	W	T	F	S
						1
2	3	4	5	6	7	8
9	10	11	12	13	14	15
16	17	18	19	20	21	22
23	24	25	26	27	28	29
30						

September

Father's Day (Australia, NZ)

Sunday
2

Labor Day (USA, Canada)

Monday
3

Tuesday
4

Wednesday
5

Thursday
6

Friday
7

Saturday
8

WISDOM OF SOLOMAN 13:1-9 *If through delight in the beauty of these things people assumed them to be gods, let them know how much better than these is their Lord, for the author of beauty created them. (13:3)*

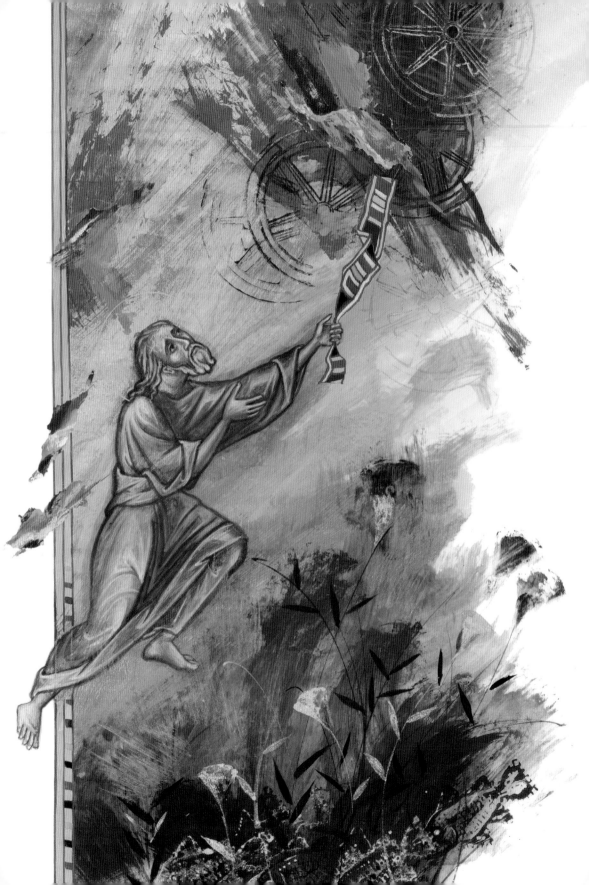

September

S M T W T F S
 1
2 3 4 5 6 7 8
9 10 11 12 13 14 15
16 17 18 19 20 21 22
23 24 25 26 27 28 29
30

September

Sunday
9

Monday
10

Tuesday
11

Wednesday
12

Thursday
13

Friday
14

Saturday
15

2 KINGS 1–18 *As they continued walking and talking, a chariot of fire and horses of fire separated the two of them, and Elijah ascended in a whirlwind into heaven. (2:11)*

FOR THUS SAYS THE LORD:

I will extend prosperity to her

like a river

and the wealth of the nations

like a overflowing stream

and you shall nurse

And be carried on her arm

And dandled on her knees.

As a mother comforts her child

So I will comfort you

and shall be comforted in Jerusalem.

September

S M T W T F S
						1
2	3	4	5	6	7	8
9	10	11	12	13	14	15
16	17	18	19	20	21	22
23	24	25	26	27	28	29
30						

September

*Begins at sundown the previous day

Sunday
16

Rosh Hashanah*

Monday
17

Rosh Hashanah ends

Tuesday
18

Wednesday
19

Thursday
20

U.N. International Day of Peace

Friday
21

Saturday
22

ISAIAH 66:1-16 *For thus says the LORD: I will extend prosperity to her like a river, and the wealth of the nations like an overflowing stream; and you shall nurse and be carried on her arm, and dandled on her knees. As a mother comforts her child, so I will comfort you; you shall be comforted in Jerusalem. (66:12-13)*

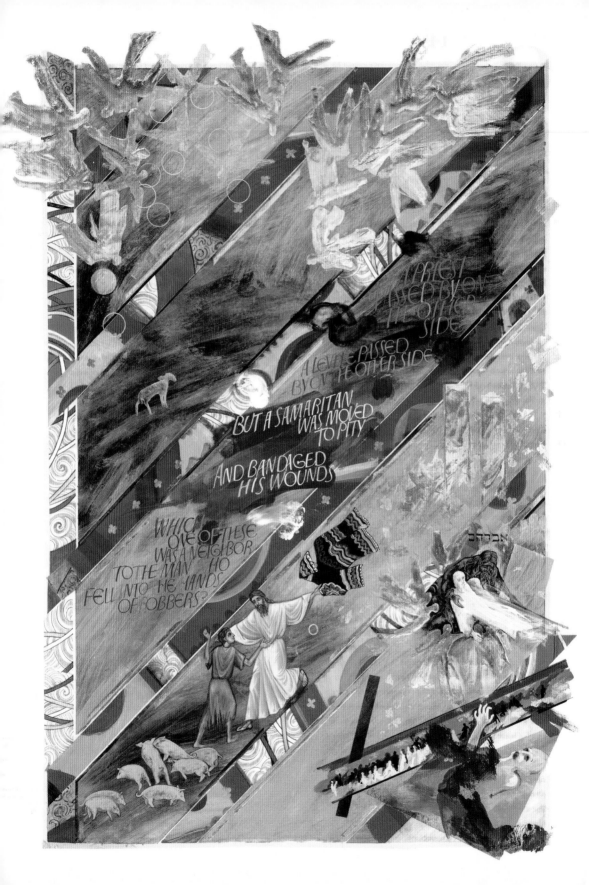

September

S	M	T	W	T	F	S
						1
2	3	4	5	6	7	8
9	10	11	12	13	14	15
16	17	18	19	20	21	22
23	24	25	26	27	28	29
30						

September

*Begins at sundown the previous day

Sunday
23

Monday
24

Tuesday
25

Yom Kippur*

Wednesday
26

Thursday
27

Friday
28

Saturday
29

LUKE 10:25-37 *"Which of these three, do you think, was a neighbor to the man who fell into the hands of the robbers?" (10:36)*

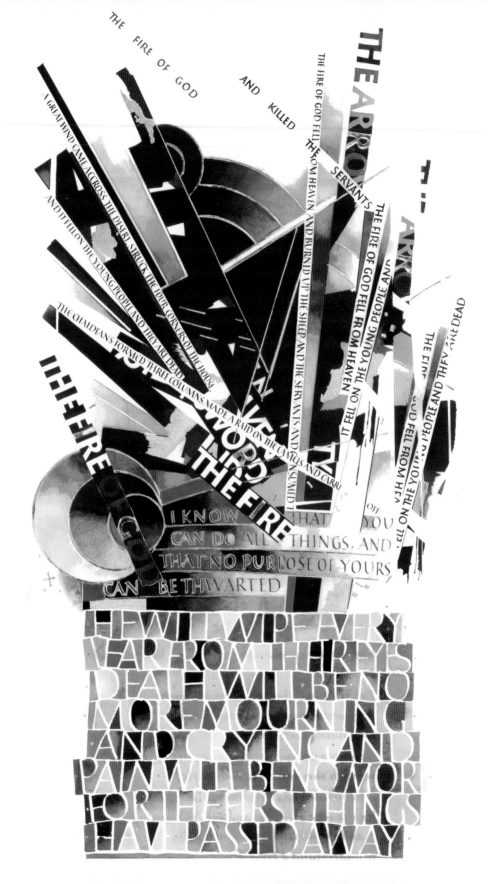

September

S	M	T	W	T	F	S
						1
2	3	4	5	6	7	8
9	10	11	12	13	14	15
16	17	18	19	20	21	22
23	24	25	26	27	28	29
30						

October

S	M	T	W	T	F	S
	1	2	3	4	5	6
7	8	9	10	11	12	13
14	15	16	17	18	19	20
21	22	23	24	25	26	27
28	29	30	31			

Sept-Oct

Sunday
30

Monday
1

Labour Day (Australia—ACT, NSW, SA)

Queen's Birthday (Australia—WA)

Tuesday
2

Wednesday
3

Thursday
4

Friday
5

Saturday
6

JOB 42:1-6 *"I know that you can do all things, and that no purpose of yours can be thwarted."* *(42:2)*

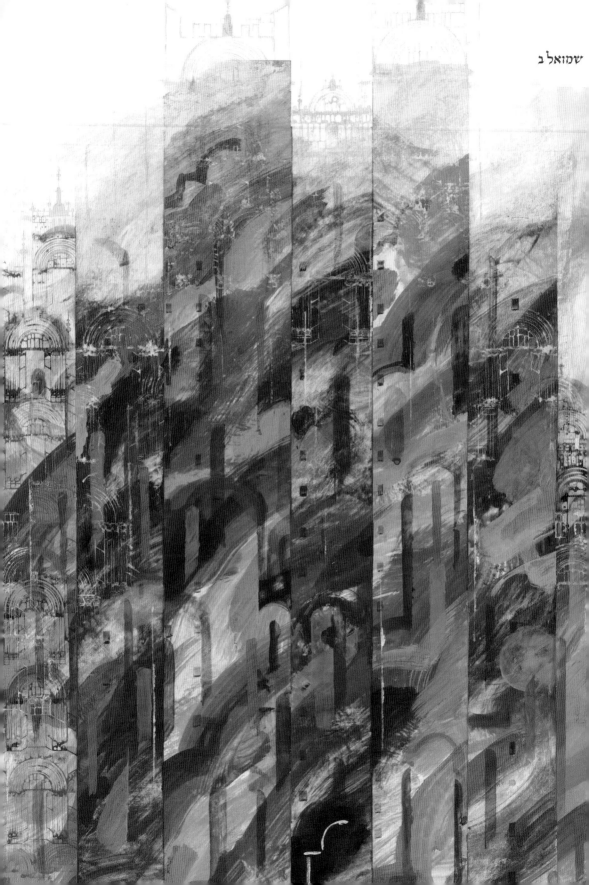

October

S	M	T	W	T	F	S
	1	2	3	4	5	6
7	8	9	10	11	12	13
14	15	16	17	18	19	20
21	22	23	24	25	26	27
28	29	30	31			

October

Sunday
7

Monday
8

Columbus Day (USA)

Thanksgiving (Canada)

Tuesday
9

Wednesday
10

Thursday
11

Friday
12

Saturday
13

2 SAMUEL *At the end of four years Absalom said to the king, "Please let me go to Hebron and pay the vow that I have made to the LORD. For your servant made a vow while I lived at Geshur in Aram: If the LORD will indeed bring me back to Jerusalem, then I will worship the LORD in Hebron." (15:7-9)*

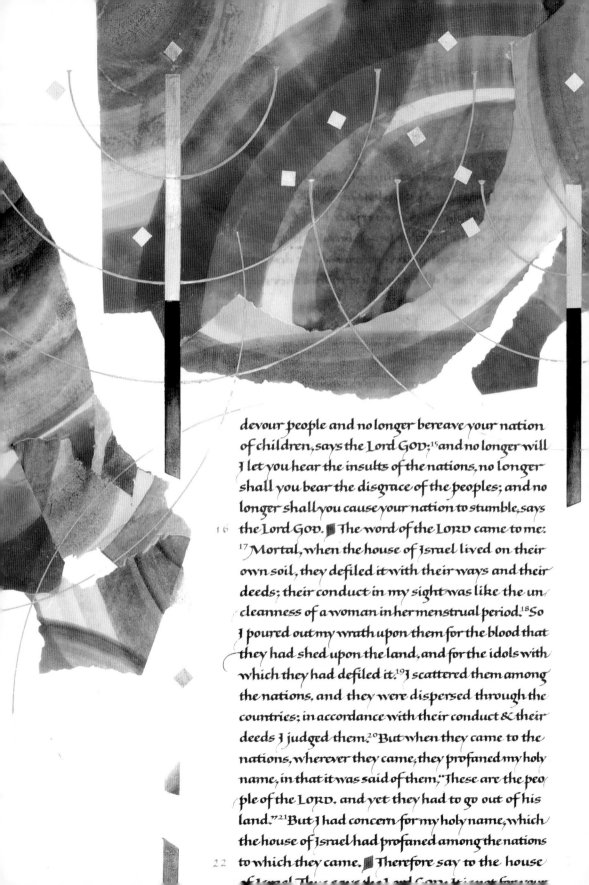

devour people and no longer bereave your nation of children, says the Lord GOD; [15]and no longer will I let you hear the insults of the nations, no longer shall you bear the disgrace of the peoples; and no longer shall you cause your nation to stumble, says the Lord GOD. ❡ The word of the LORD came to me: [17]Mortal, when the house of Israel lived on their own soil, they defiled it with their ways and their deeds; their conduct in my sight was like the uncleanness of a woman in her menstrual period. [18]So I poured out my wrath upon them for the blood that they had shed upon the land, and for the idols with which they had defiled it. [19]I scattered them among the nations, and they were dispersed through the countries; in accordance with their conduct & their deeds I judged them. [20]But when they came to the nations, wherever they came, they profaned my holy name, in that it was said of them, "These are the people of the LORD, and yet they had to go out of his land." [21]But I had concern for my holy name, which the house of Israel had profaned among the nations to which they came. ❡ Therefore say to the house

October

S	M	T	W	T	F	S
	1	2	3	4	5	6
7	8	9	10	11	12	13
14	15	16	17	18	19	20
21	22	23	24	25	26	27
28	29	30	31			

October

Sunday
14

Monday
15

Tuesday
16

Wednesday
17

Thursday
18

Friday
19

Saturday
20

EZEKIEL 37:11-14 *"I will put my spirit within you, and you shall live, and I will place you on your own soil; then you shall know that I, the LORD, have spoken and will act, says the LORD."* *(37:14)*

He shall judge
between the nations
and shall arbitrate
for many peoples

they shall beat their
swords into plowshares
and their spears
into pruning hooks

NATION·SHALL·NOT·LIFT·UP·
SWORD·AGAINST·NATION·
NEITHER·SHALL·THEY·
·LEARN·WAR·ANY·MORE·

October

S M T W T F S
 1 2 3 4 5 6
7 8 9 10 11 12 13
14 15 16 17 18 19 20
21 22 23 24 25 26 27
28 29 30 31

October

Sunday
21

Labour Day (NZ)

Monday
22

Tuesday
23

United Nations Day

Wednesday
24

Thursday
25

Eid al-Adha

Friday
26

Saturday
27

ISAIAH 2 *He shall judge between the nations, and shall arbitrate for many peoples; they shall beat their swords into plowshares, and their spears into pruning hooks; nation shall not lift up sword against nation, neither shall they learn war any more. (2:4)*

THE ALIEN WHO
RESIDES WITH YOU
SHALL BE TO YOU AS THE
CITIZEN AMONG YOU

YOU SHALL LOVE THE
ALIEN AS YOURSELF
FOR YOU WERE ALIENS
IN THE LAND OF EGYPT

I AM THE LORD YOUR GOD

October

S	M	T	W	T	F	S
	1	2	3	4	5	6
7	8	9	10	11	12	13
14	15	16	17	18	19	20
21	22	23	24	25	26	27
28	29	30	31			

November

S	M	T	W	T	F	S
				1	2	3
4	5	6	7	8	9	10
11	12	13	14	15	16	17
18	19	20	21	22	23	24
25	26	27	28	29	30	

Oct-Nov

Sunday

28

Bank Holiday (Ireland)

Monday

29

Tuesday

30

Halloween

Wednesday

31

Thursday

1

Friday

2

Saturday

3

LEVITICUS 19 *The alien who resides with you shall be to you as the citizen among you; you shall love the alien as yourself, for you were aliens in the land of Egypt: I am the LORD your God. (19:34)*

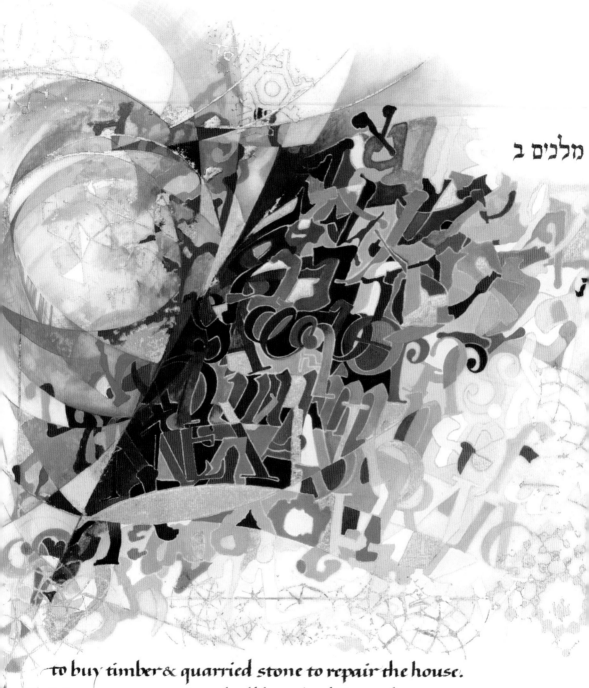

to buy timber & quarried stone to repair the house.
⁷ But no accounting shall be asked from them for
the money that is delivered into their hand, for they
8 deal honestly." ▪ The high priest Hilkiah said to
Shaphan the secretary, "I have found the book of
the law in the house of the LORD." When Hilkiah
gave the book to Shaphan, he read it.⁹ Then Shaphan

November

S	M	T	W	T	F	S
				1	2	3
4	5	6	7	8	9	10
11	12	13	14	15	16	17
18	19	20	21	22	23	24
25	26	27	28	29	30	

November

Sunday
4

Monday
5

Election Day (USA)

Tuesday
6

Wednesday
7

Thursday
8

Friday
9

Saturday
10

2 KINGS 22 *"Therefore, I will gather you to your ancestors, and you shall be gathered to your grave in peace; your eyes shall not see all the disaster that I will bring on this place." They took the message back to the king. (22:20)*

THEN I SAID "AH LORD
GOD TRULY I DO NOT
KNOW HOW TO SPEAK
FOR I AM ONLY A BOY
BUT THE LORD SAID TO ME

THEN THE LORD PUT OUT
HIS HAND AND TOUCHED
MY MOUTH AND THE
LORD SAID TO ME

November

S	M	T	W	T	F	S	
					1	2	3
4	5	6	7	8	9	10	
11	12	13	14	15	16	17	
18	19	20	21	22	23	24	
25	26	27	28	29	30		

November

Veterans' Day (USA)

Remembrance Day (Canada, Ireland, UK)

Sunday
11

Veterans' Day (observed) (USA)

Monday
12

Tuesday
13

Wednesday
14

Thursday
15

Friday
16

Saturday
17

JEREMIAH 1:4-10 *"Before I formed you in the womb I knew you, and before you were born I consecrated you; I appointed you a prophet to the nations." (1:5)*

November

S M T W T F S
 1 2 3
4 5 6 7 8 9 10
11 12 13 14 15 16 17
18 19 20 21 22 23 24
25 26 27 28 29 30

November

Sunday
18

Monday
19

Tuesday
20

Wednesday
21

Thanksgiving (USA)

Thursday
22

Friday
23

Saturday
24

PSALM 42 *By day the* LORD *commands his steadfast love, and at night his song is with me, a prayer to the God of my life. (42:8)*

He has told you
O mortal
what is good

and what does
the LORD require of you
but to do justice
and to love kindness
& to walk humbly
with your God

November

S	M	T	W	T	F	S
				1	2	3
4	5	6	7	8	9	10
11	12	13	14	15	16	17
18	19	20	21	22	23	24
25	26	27	28	29	30	

December

S	M	T	W	T	F	S
						1
2	3	4	5	6	7	8
9	10	11	12	13	14	15
16	17	18	19	20	21	22
23	24	25	26	27	28	29
30	31					

Nov-Dec

Sunday
25

Monday
26

Tuesday
27

Wednesday
28

Thursday
29

St. Andrew's Day (UK)

Friday
30

Saturday
1

MICAH 6:6-8 *He has told you, O mortal, what is good; and what does the LORD require of you but to do justice, and to love kindness, and to walk humbly with your God? (6:8)*

December

S	M	T	W	T	F	S
						1
2	3	4	5	6	7	8
9	10	11	12	13	14	15
16	17	18	19	20	21	22
23	24	25	26	27	28	29
30	31					

December

Sunday

2

Monday

3

Tuesday

4

Wednesday

5

Thursday

6

Friday

7

Saturday

8

2 SAMUEL 6:1–7:3 *They brought in the ark of the LORD, and set it in its place, inside the tent that David had pitched for it; and David offered burnt offerings and offerings of well-being before the LORD. (6:17)*

SET ME AS A SEAL
UPON YOUR HEART
AS A SEAL UPON
YOUR ARM
FOR LOVE IS
STRONG AS DEATH
PASSION FIERCE
AS THE GRAVE
ITS FLASHES ARE
FLASHES OF FIRE
A RAGING FLAME
MANY WATERS CAN
NOT QUENCH LOVE
NEITHER CAN
FLOODS DROWN IT
IF ONE OFFERED
FOR LOVE
ALL THE WEALTH
OF ONE'S HOUSE
IT WOULD BE
UTTERLY SCORNED

December

S	M	T	W	T	F	S
						1
2	3	4	5	6	7	8
9	10	11	12	13	14	15
16	17	18	19	20	21	22
23	24	25	26	27	28	29
30	31					

December

*Begins at sundown the previous day

Hanukkah*

Sunday
9

Human Rights Day

Monday
10

Tuesday
11

Wednesday
12

Thursday
13

Friday
14

Saturday
15

SONG OF SOLOMON 8:6-7 *Many waters cannot quench love, neither can floods drown it. If one offered for love all the wealth of one's house, it would be utterly scorned. (8:7)*

December

S	M	T	W	T	F	S
						1
2	3	4	5	6	7	8
9	10	11	12	13	14	15
16	17	18	19	20	21	22
23	24	25	26	27	28	29
30	31					

December

Hanukkah ends

Sunday
16

Monday
17

Tuesday
18

Wednesday
19

Thursday
20

Friday
21

Saturday
22

SIRACH 39:13-15 *Listen to me, my faithful children, and blossom like a rose growing by a stream of water. (39:13)*

"Do not be afraid; for see — I am bringing you good news of great joy for all the people: [11] to you is born this day in the city of David a Savior, who is the Messiah, the Lord. [12] This will be a sign for you: you will find a child wrapped in bands of cloth and lying in a manger." [13] And suddenly there was with the angel a multitude of the heavenly host, praising God & saying,

[14] GLORY TO GOD IN THE HIGHEST HEAVEN & ON EARTH PEACE AMONG THOSE WHOM HE FAVORS!"

[15] When the angels had left them & gone into heaven, the shepherds said to one another, "Let us go now to Bethlehem and see this thing that has taken place, which the Lord has made known to us." [16] So they went with haste and found Mary and Joseph, and the child lying in the manger. [17] When they saw this, they made known what had been told them about this child; [18] and all who heard it were amazed at what the shepherds told them. [19] But Mary treasured all these words and pondered them in her heart. [20] The shepherds returned, glorifying and praising God for all they had heard and seen, as it

December

S	M	T	W	T	F	S
						1
2	3	4	5	6	7	8
9	10	11	12	13	14	15
16	17	18	19	20	21	22
23	24	25	26	27	28	29
30	31					

December

Sunday
23

Christmas Eve

Monday
24

Christmas Day

Tuesday
25

Kwanzaa begins (USA)

Boxing Day (Canada, UK, NZ, Australia—except SA)

St. Stephen's Day (Ireland)

Proclamation Day (Australia—SA)

Wednesday
26

Thursday
27

Friday
28

Saturday
29

LUKE 2:8-20 *"To you is born this day in the city of David a Savior, who is the Messiah, the Lord." (2:11)*

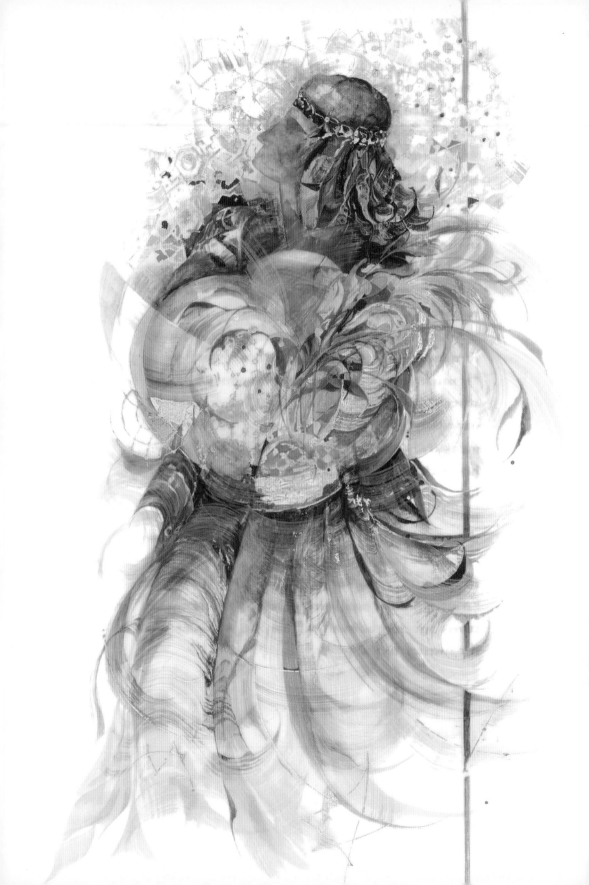

December

S	M	T	W	T	F	S
						1
2	3	4	5	6	7	8
9	10	11	12	13	14	15
16	17	18	19	20	21	22
23	24	25	26	27	28	29
30	31					

January 2013

S	M	T	W	T	F	S
		1	2	3	4	5
6	7	8	9	10	11	12
13	14	15	16	17	18	19
20	21	22	23	24	25	26
27	28	29	30	31		

Dec-Jan 2013

Sunday
30

Monday
31

New Year's Day

Kwanzaa ends (USA)

Tuesday
1

New Year's Day (observed) (NZ)

Bank Holiday (UK—Scotland)

Wednesday
2

Thursday
3

Friday
4

Saturday
5

RUTH 2 *"May the LORD reward you for your deeds, and may you have a full reward from the LORD, the God of Israel, under whose wings you have come for refuge!" (2:12)*

2013

January

February

March

April

May

June

2013

July

August

September

October

November

December

2011

January
S	M	T	W	T	F	S
						1
2	3	4	5	6	7	8
9	10	11	12	13	14	15
16	17	18	19	20	21	22
23	24	25	26	27	28	29
30	31					

February
S	M	T	W	T	F	S
		1	2	3	4	5
6	7	8	9	10	11	12
13	14	15	16	17	18	19
20	21	22	23	24	25	26
27	28					

March
S	M	T	W	T	F	S
		1	2	3	4	5
6	7	8	9	10	11	12
13	14	15	16	17	18	19
20	21	22	23	24	25	26
27	28	29	30	31		

April
S	M	T	W	T	F	S
					1	2
3	4	5	6	7	8	9
0	11	12	13	14	15	16
17	18	19	20	21	22	23
24	25	26	27	28	29	30

May
S	M	T	W	T	F	S
1	2	3	4	5	6	7
8	9	10	11	12	13	14
15	16	17	18	19	20	21
22	23	24	25	26	27	28
29	30	31				

June
S	M	T	W	T	F	S
			1	2	3	4
5	6	7	8	9	10	11
12	13	14	15	16	17	18
19	20	21	22	23	24	25
26	27	28	29	30		

July
S	M	T	W	T	F	S
					1	2
3	4	5	6	7	8	9
10	11	12	13	14	15	16
17	18	19	20	21	22	23
24	25	26	27	28	29	30
31						

August
S	M	T	W	T	F	S
	1	2	3	4	5	6
7	8	9	10	11	12	13
14	15	16	17	18	19	20
21	22	23	24	25	26	27
28	29	30	31			

September
S	M	T	W	T	F	S
				1	2	3
4	5	6	7	8	9	10
11	12	13	14	15	16	17
18	19	20	21	22	23	24
25	26	27	28	29	30	

October
S	M	T	W	T	F	S
						1
2	3	4	5	6	7	8
9	10	11	12	13	14	15
16	17	18	19	20	21	22
23	24	25	26	27	28	29
30	31					

November
S	M	T	W	T	F	S
		1	2	3	4	5
6	7	8	9	10	11	12
13	14	15	16	17	18	19
20	21	22	23	24	25	26
27	28	29	30			

December
S	M	T	W	T	F	S
				1	2	3
4	5	6	7	8	9	10
11	12	13	14	15	16	17
18	19	20	21	22	23	24
25	26	27	28	29	30	31

2013

January
S	M	T	W	T	F	S
		1	2	3	4	5
6	7	8	9	10	11	12
13	14	15	16	17	18	19
20	21	22	23	24	25	26
27	28	29	30	31		

February
S	M	T	W	T	F	S
					1	2
3	4	5	6	7	8	9
10	11	12	13	14	15	16
17	18	19	20	21	22	23
24	25	26	27	28		

March
S	M	T	W	T	F	S
					1	2
3	4	5	6	7	8	9
10	11	12	13	14	15	16
17	18	19	20	21	22	23
24	25	26	27	28	29	30
31						

April
S	M	T	W	T	F	S
	1	2	3	4	5	6
7	8	9	10	11	12	13
14	15	16	17	18	19	20
21	22	23	24	25	26	27
28	29	30				

May
S	M	T	W	T	F	S
			1	2	3	4
5	6	7	8	9	10	11
12	13	14	15	16	17	18
19	20	21	22	23	24	25
26	27	28	29	30	31	

June
S	M	T	W	T	F	S
						1
2	3	4	5	6	7	8
9	10	11	12	13	14	15
16	17	18	19	20	21	22
23	24	25	26	27	28	29
30						

July
S	M	T	W	T	F	S
	1	2	3	4	5	6
7	8	9	10	11	12	13
14	15	16	17	18	19	20
21	22	23	24	25	26	27
28	29	30	31			

August
S	M	T	W	T	F	S
				1	2	3
4	5	6	7	8	9	10
11	12	13	14	15	16	17
8	19	20	21	22	23	24
25	26	27	28	29	30	31

September
S	M	T	W	T	F	S
1	2	3	4	5	6	7
8	9	10	11	12	13	14
15	16	17	18	19	20	21
22	23	24	25	26	27	28
29	30					

October
S	M	T	W	T	F	S
		1	2	3	4	5
6	7	8	9	10	11	12
13	14	15	16	17	18	19
20	21	22	23	24	25	26
27	28	29	30	31		

November
S	M	T	W	T	F	S
					1	2
3	4	5	6	7	8	9
10	11	12	13	14	15	16
17	18	19	20	21	22	23
24	25	26	27	28	29	30

December
S	M	T	W	T	F	S
1	2	3	4	5	6	7
8	9	10	11	12	13	14
15	16	17	18	19	20	21
22	23	24	25	26	27	28
29	30	31				